Remembering
El Paso

Sandra Fye

TURNER

PUBLISHING COMPANY

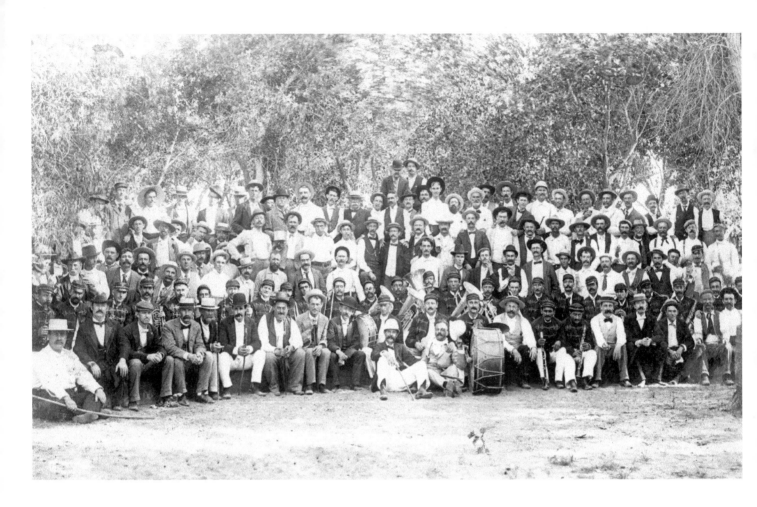

The McGinty Club picnic at Orn's Grove, in 1892. The McGinty Club was a group of men who liked to drink, play music, march, have parades, and have a good time. The club was led by Daniel W. Reckbart and was named after a song that was popular at the time. In the early days of El Paso, the McGinty Club provided the community with comedy and other entertainment and always made a point to dress well. The club was active until about 1905, when members formed other clubs, such as the Toltec Club.

Remembering
El Paso

Turner Publishing Company
www.turnerpublishing.com

Remembering El Paso

Library of Congress Control Number: 2010926208

ISBN: 978-1-59652-684-6

Printed in the United States of America

ISBN 978-1-68336-828-1 (pbk.)

CONTENTS

The Rio Grande Valley Bank and Trust Building, which later became the Abdou Building, at 115 North Mesa Street in 1910. The exposed concrete structure was then the tallest building in El Paso. The bank was on the first two floors, while the upper floors housed the professional offices of the law firms of Bates McFarland; R. C. Walsh; C. W. Marshall; Goodwell and Sweeney; and the dental practice of Brandy and Letord.

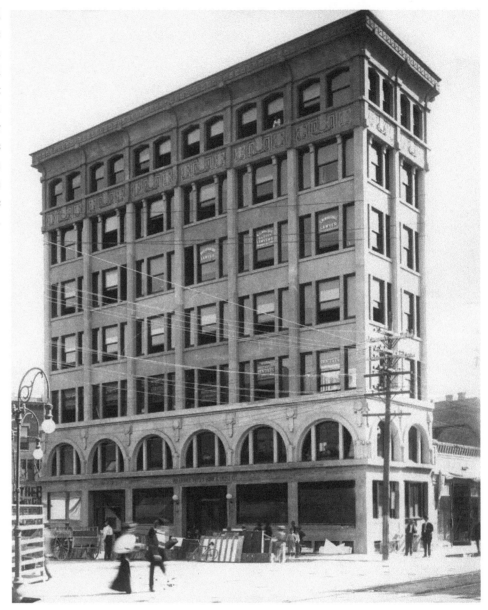

Acknowledgments

With the exception of touching up imperfections that have accrued with the passage of time and cropping where necessary, no changes have been made. The focus and clarity of many images are limited to the technology and the ability of the photographer at the time they were recorded.

This volume, *Remembering El Paso,* is the result of the cooperation and efforts of many individuals, organizations, and corporations. It is with great thanks that we acknowledge the valuable contribution of the following for their generous support:

El Paso County Historical Society
El Paso Public Library
Library of Congress

The El Paso Public Library provided a nice environment to learn about the history of El Paso. Danny Gonzalez and Claudia Ramirez had photo-graphs from the Border Heritage Center set aside for me to look at, which was a very big help. I am grateful for the information available on the World Wide Web and thank all of you who post historical articles. For the loan of El Paso books and the enthusiastic sharing of El Paso stories, thank you Stefan Kosicki. To Lieutenant Colonel Rufino De La Cruz, USMC retired; Vanessa De La Cruz; and Juliette De La Cruz, I appreciate the help identifying pictures Glenn, Mo, and Debbi provided help and encouragement; muchas gracias a mis amigos. I hope you all enjoy the book!

PREFACE

Native Americans have been in the El Paso area for around 10,000 years. The Keystone Wetlands and Hueco Tanks sites are both about 4,500 years old. The native people followed the Rio Grande and traded along its path. In 1598, Don Juan de Oñate traveled north along the Rio Grande with a large caravan from Zacatecas, Mexico, to what became known as El Paso del Norte. Near San Elizario, Oñate claimed the area for Spain, and it became a trade center along El Camino Real, the Royal Highway, which went north all the way to the Española Valley in New Mexico.

In 1659, a mission was founded at what is now Ciudad Juárez to convert the Manso people to Catholicism. Mission Nuestra Señora de Guada-lupe was started in 1662, and when finished in 1668 was considered the best in the Custodia de Nuevo México. During the Pueblo Revolt of 1680, about 2,000 people traveled south to El Paso del Norte missions to seek refuge.

Mexico won its independence from Spain in 1821, so the area became part of Mexico, and trade was allowed with the United States. This part of the Camino Real became known as the Chihuahuan Trail. In 1845, the Republic of Texas became part of the United States, and the settlement of Franklin was started on the north side of the Rio Grande. With the 1848 signing of the Treaty of Guadalupe Hidalgo, the Rio Grande became the international boundary between the United States and Mexico.

In 1848, the United States Army sent units to defend the territory gained in the Mexican War, protect settlers, and maintain the law. Two infantry companies were stationed at San Elizario and four at the Post Opposite El Paso, later renamed Fort Bliss, across the Rio Grande from the settlement then called El Paso del Norte. In 1890, legislation was passed to construct new Fort Bliss buildings at La Noria Mesa, near Concordia. The construction was completed in 1893.

In 1852, a post office was established at Franklin. The Butterfield Overland Mail and Stage arrived in 1858 and passed through twice a week. Brigadier General Anson Mills built the station and corrals for the stage on two acres at El Paso, Overland, and Oregon streets. Across the street from the station was the post office, a store, and a bar. In 1859, Mills surveyed the town, and the sketch of it shows a plaza, a public square, streets, and the *acequia*

madre (mother irrigation ditch) east of the plaza. Mills also changed the name of Franklin to El Paso. Magoffinsville, Hart's Mill, and Concordia were settlements in the area. El Paso was incorporated as a city in 1873. Across the river, El Paso del Norte was renamed Ciudad Juárez in 1888.

The arrival of the Southern Pacific; the Texas and Pacific; and the Atchison, Topeka and Santa Fe railroads in 1881 brought in many people, in-cluding the Chinese laborers who built them. El Paso was considered a Wild West outpost and had gunfighters, prostitutes, gamblers, outlaws, and dancehall girls. The El Paso and Southwestern Railroad, owned by the Phelps-Dodge Company, brought copper to El Paso from Bisbee, Arizona.

El Paso had roughly 4,000 residents in 1909 when photographer Otis Aultman moved there. He was 35 years old and had learned photography from his brother. Hired by Homer A. Scott, of the Scott Photo Company, Aultman took pictures of the historic 1909 meeting between presidents William Howard Taft of the United States and Porfirio Díaz of Mexico. Over time, news photos by Aultman would be featured often in full-page spreads in the El Paso papers. He also did commercial photography for the architecture firm of Trost and Trost, and with an interest in archaeology and history, he served as vice-president of the El Paso Archaeological Society.

On March 5, 1943, Aultman died in his studio. His photograph collection, from which many of the historic images in this book have been drawn, now resides at the El Paso Public Library.

—*Sandra Fye*

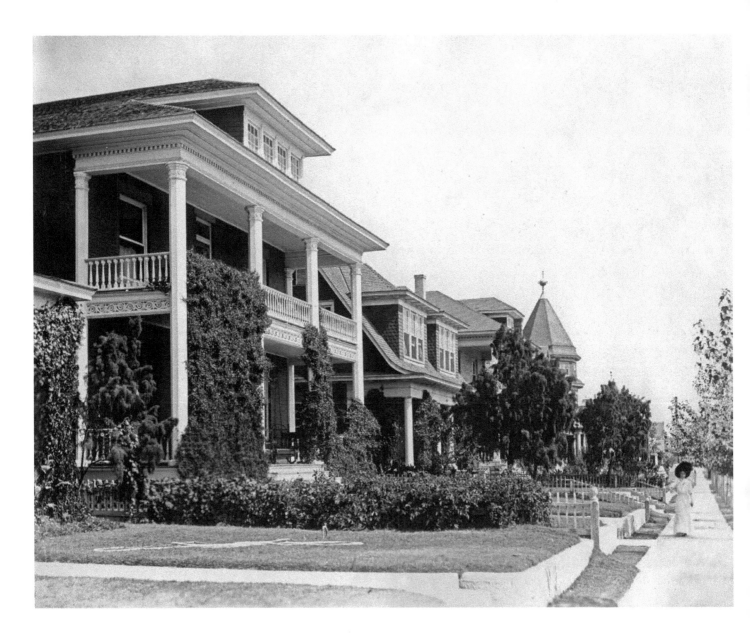

A tranquil walk down Montana Avenue. The 1000–1500 section of Montana Avenue is a historic district on the National Register of Historic Places. Henry C. Trost built many of the homes there, which now house offices and apartments.

THE EARLY DAYS OF EL PASO

(1880–1899)

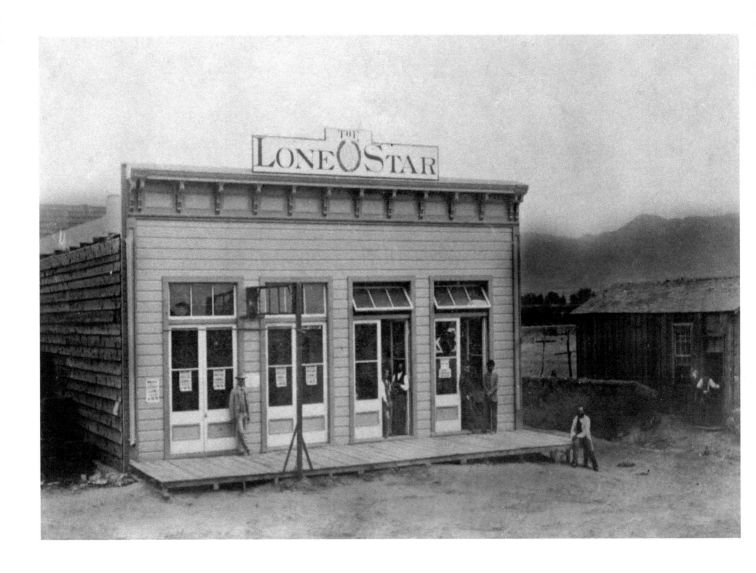

The *Lone Star* Building stood at 10 West Overland Avenue. The *Lone Star* was a newspaper owned by Simeon Harrison Newman that appeared on Wednesdays and Saturdays starting in 1881. Newman was involved in city politics and the founding of the White Oaks Railroad. He fought for public schools, good utilities, and a fire department, using his newspaper as a forum for his ideas.

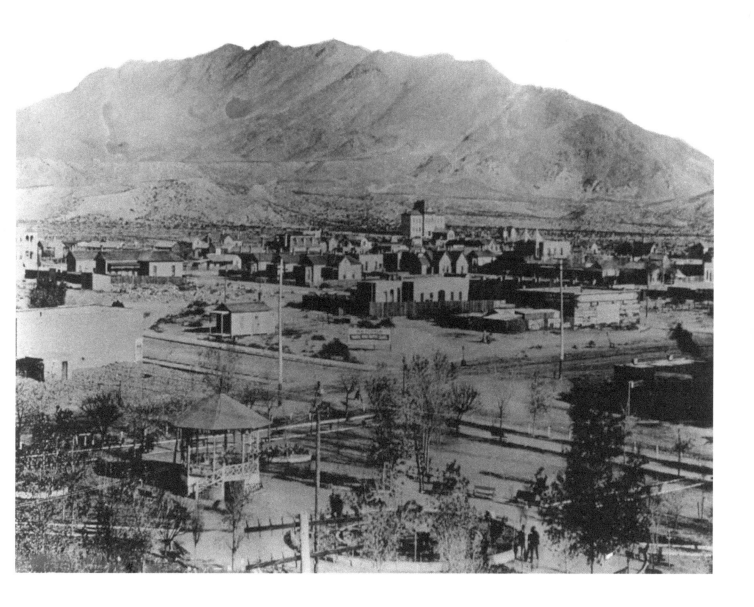

Looking northeast, from San Jacinto Plaza, toward the Franklin Mountains. The Gilbert brothers donated the land for a town square in 1857. The plaza was a pleasant place to stroll with friends and family and to enjoy the view of the mountains, especially at sunrise and sunset. Many people still enjoy walking around San Jacinto Plaza and sitting on the plaza benches talking to friends.

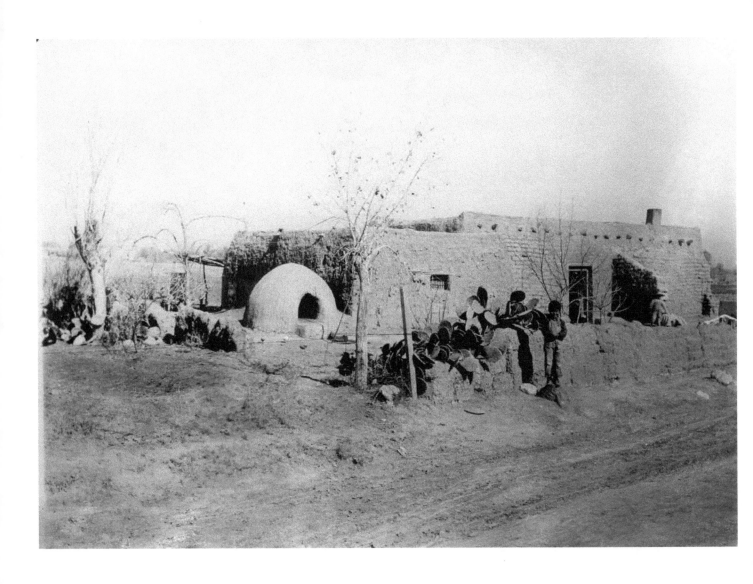

This is a typical adobe home of the late nineteenth century. Hornos (adobe ovens) were used to bake bread, corn, and tortillas. Adobe bricks are made of mud and straw, then sun-dried in forms, typically with the whole family helping in the enterprise. In 1854, when the area was known as Franklin, adobe homes were along the trail that was to become El Paso Street. When the railroads were built to El Paso, many other types of building materials started being used.

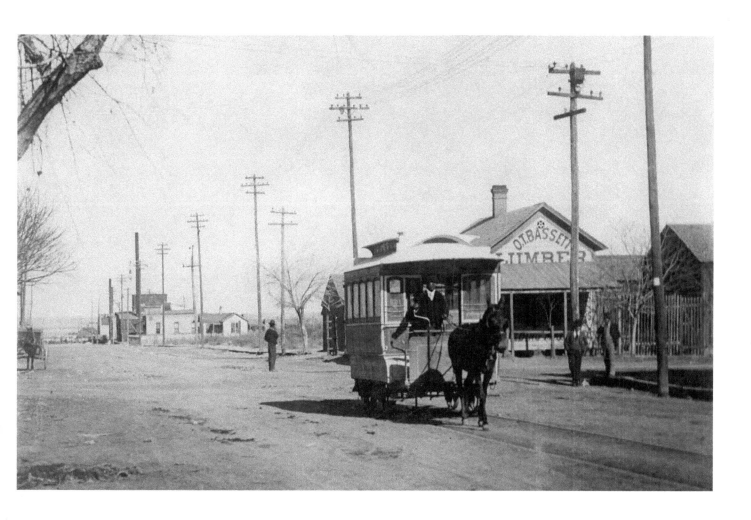

The mule car trolley is passing the O. T. Bassett Lumber Company, at North Mill and Stanton Street. Oscar T. Bassett met Charles Morehead while the two were traveling by stage to El Paso in 1880. When they arrived in El Paso, they had dinner with Mayor Joseph Magoffin and bought 400 acres of land from him for the Texas and Pacific Railroad. Bassett, Morehead, and a group of St. Louis investors started the State National Bank in 1881.

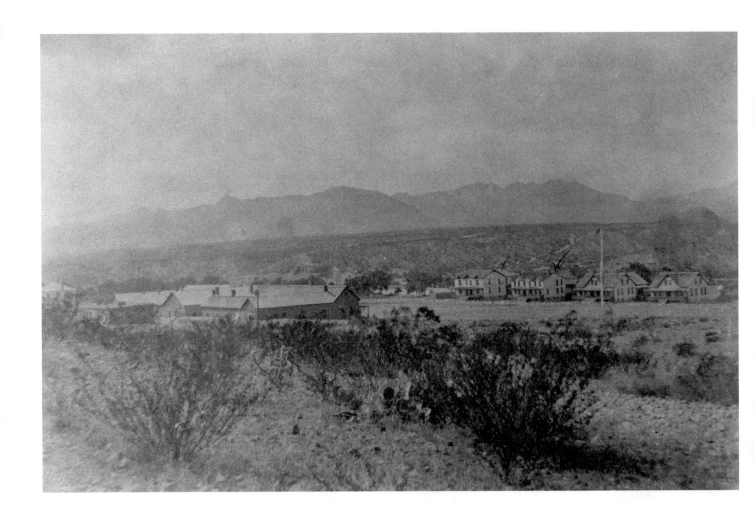

Fort Bliss at Hart's Mill, where Mexican War veteran Simeon Hart had his flour mill, El Molino. After the regional "Salt War" violence of 1877, the United States government bought 135 acres at Hart's Mill for Fort Bliss. In 1893, Fort Bliss moved to La Noria Mesa. The fort was named after Mexican War veteran Lieutenant Colonel William Wallace Smith Bliss.

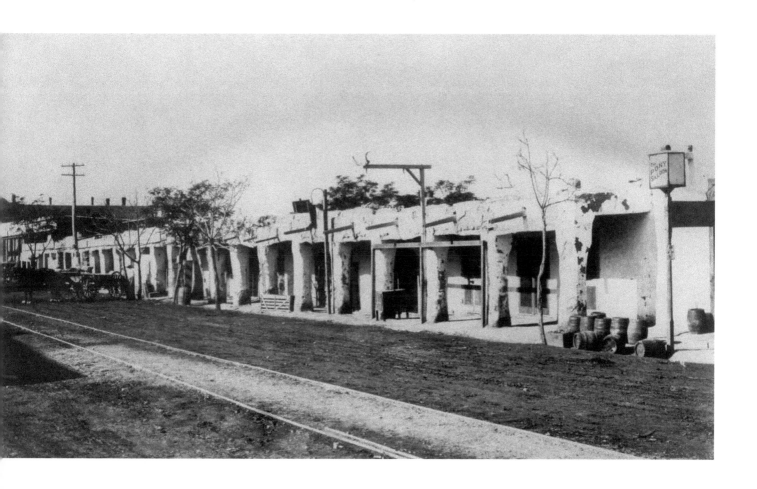

South El Paso Street was the center of town, as seen here in 1882. The sign on the right is for the Pony Saloon, which has a stack of empty beer barrels next to it. El Paso Street was the scene of a famous shootout involving Marshal Dallas Stoudenmire, John Hale, Gus Krempkau, and George Campbell. Stoudenmire was killed in a saloon on El Paso Street in September 1882. Masonic Lodge No. 130 paid for his funeral expenses.

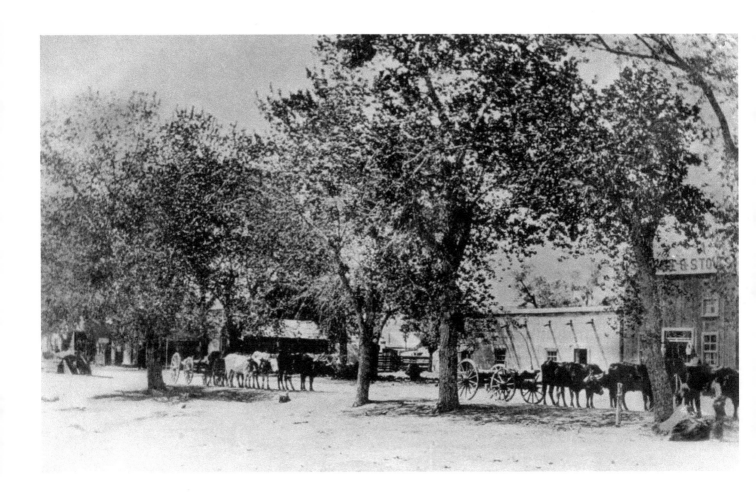

An 1882 view of San Antonio Avenue and El Paso Street. Heavily laden wagons, drawn by teams of oxen, transported goods up and down the Camino Real before the railroad came. After the railroad reached El Paso, the freight wagons were used to transport goods to places not served by the rails. The early pioneers also used these wagons to move their families to new places.

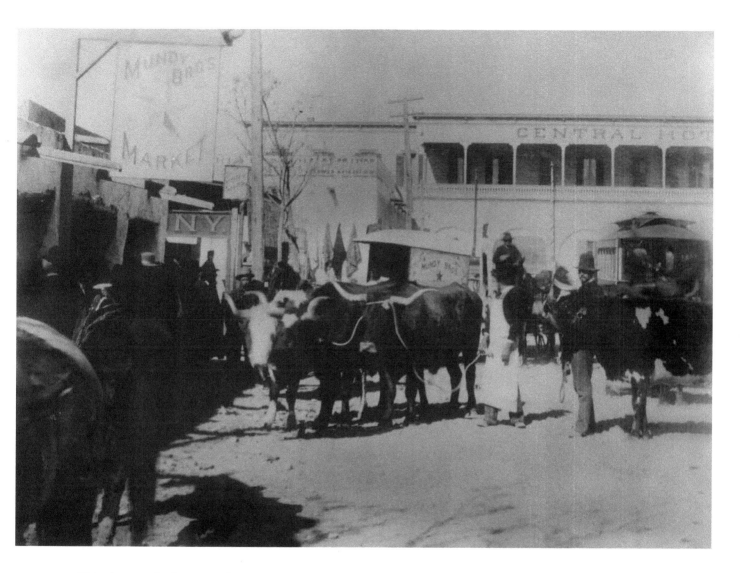

This photograph of Pioneer Plaza was taken by Ben Wittick in 1882. On the right is the Central Hotel, fronting South El Paso Street, and to the hotel's left is the Casa Grande Dry Goods Store. A sign for the Pony Saloon, which offered entertainment for the men, is tucked up by the tall pole. On the far left is the Mundy Brothers Market, a meat market and wholesaler, with three longhorns out front. The Mundys owned a stock business that exported sheep, cattle, and horses to Mexico and sold meat and livestock in El Paso.

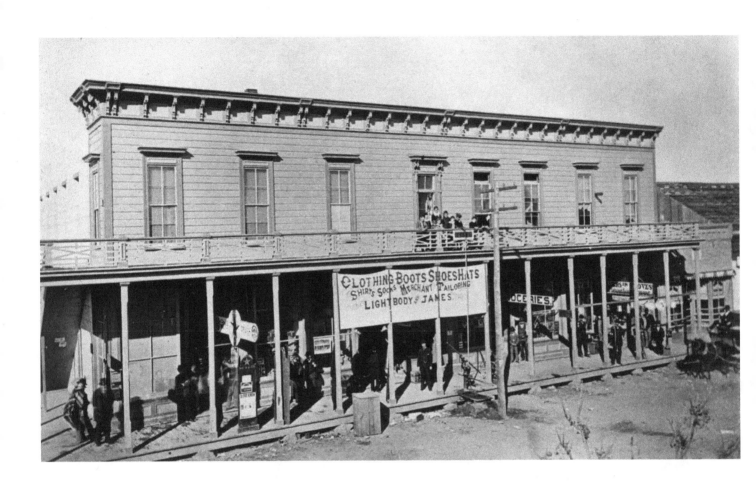

Lightbody and James Store in the Davis Block, sold clothing, boots, hats, shirts, socks, and merchant tailoring. Robert C. Lightbody was the mayor of El Paso from 1885 until 1889 and the leader of the McGinty Club Plug Hat Brigade. The store would later become R. C. Lightbody Clothing Company.

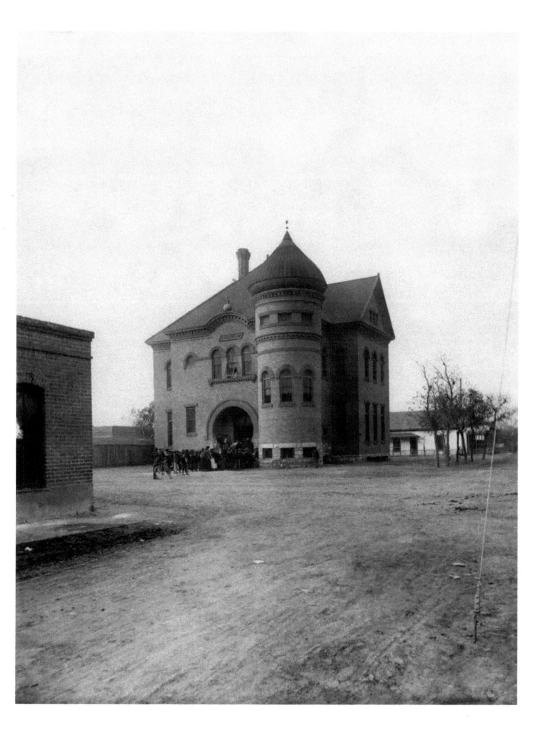

Public education started in El Paso in 1883. This is the Franklin School, at Leon Street and Overland Avenue. Also on Overland Avenue, the Butterfield Overland Mail Company operated a stage stop, and its El Paso building was the largest station on the 2,700-mile-long Overland route. Railroads eventually replaced the stage, and the Butterfield building was torn down.

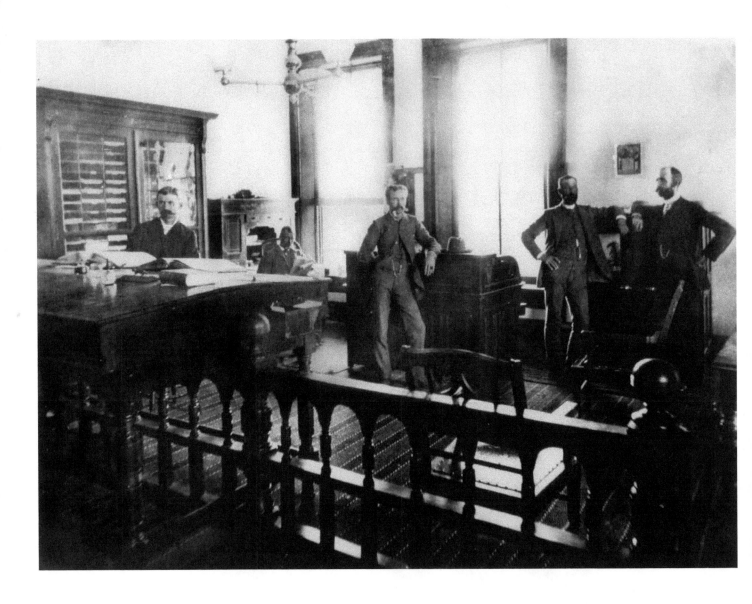

Occupying themselves at the El Paso County Courthouse are, from left, Frank Simmons, J. H. Comstock, Judge T. A. Falvey, Captain Jim White, and W. L. Maury. Judge Falvey was a federal district judge who presided over the district of Judge Roy Bean, which included El Paso, Fort Stanton, Del Rio, and other areas. The El Paso County Sheriff's office was moved to the new courthouse in 1886.

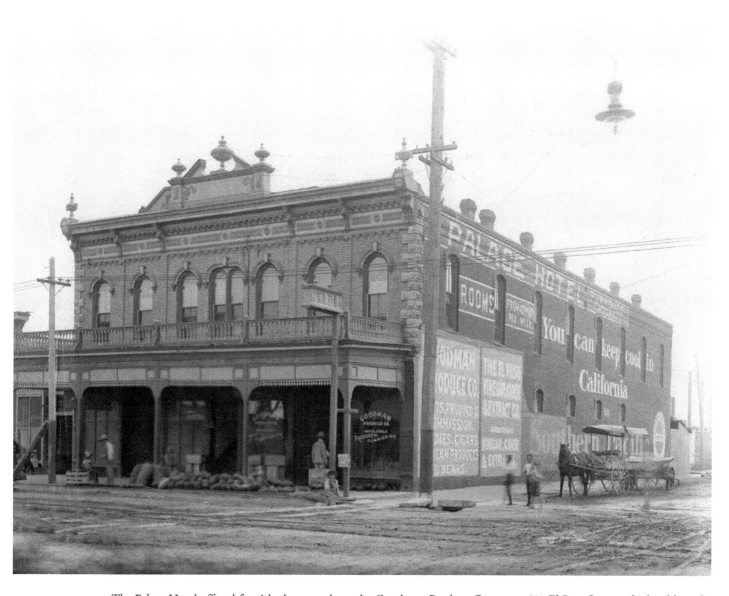

The Palace Hotel offered furnished rooms above the Goodman Produce Company, 501 El Paso Street, which sold candy and cigars in addition to produce. The El Paso Vinegar and Extract Company advertised on the side of the building was also owned by S. L. Goodman. Sharing the hotel advertising space, the Southern Pacific reminded passersby "you can keep cool in California," which the people with money would do.

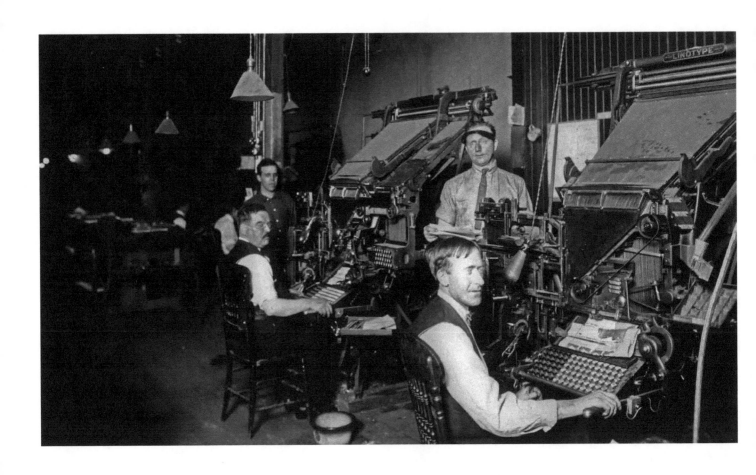

The El Paso Herald composing room seen here has a Linotype machine being used by the employees. Invented in 1886 by Otto Mergenthaler, Linotype allowed one man to do the work in composing a newspaper that used to take ten men by hand.

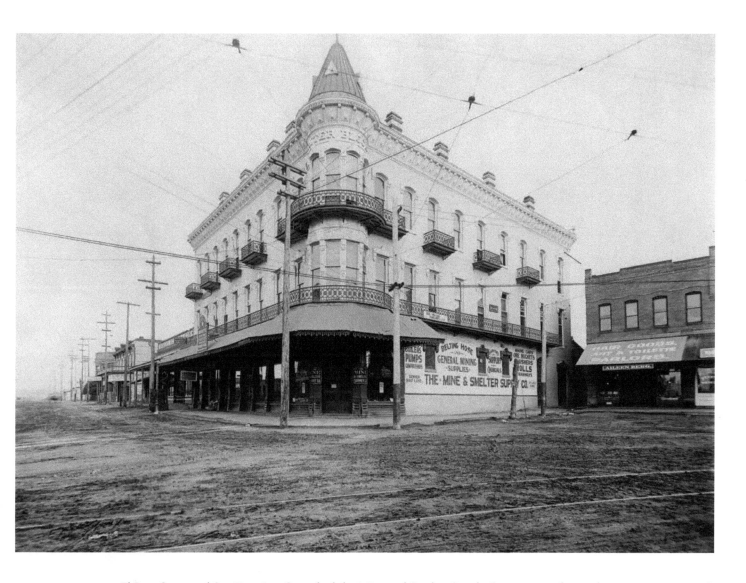

El Paso Street and San Francisco Street had the Mine and Smelter Supply Company on the northwest corner, managed by D. L. Gregg. At this point El Paso was becoming a mining center. In 1887 Robert Towne built a smelter west of downtown. Mining conventions were held in El Paso, and the Texas State School of Mines and Metallurgy, the forerunner of the University of Texas at El Paso, was approved by the state legislature in 1913.

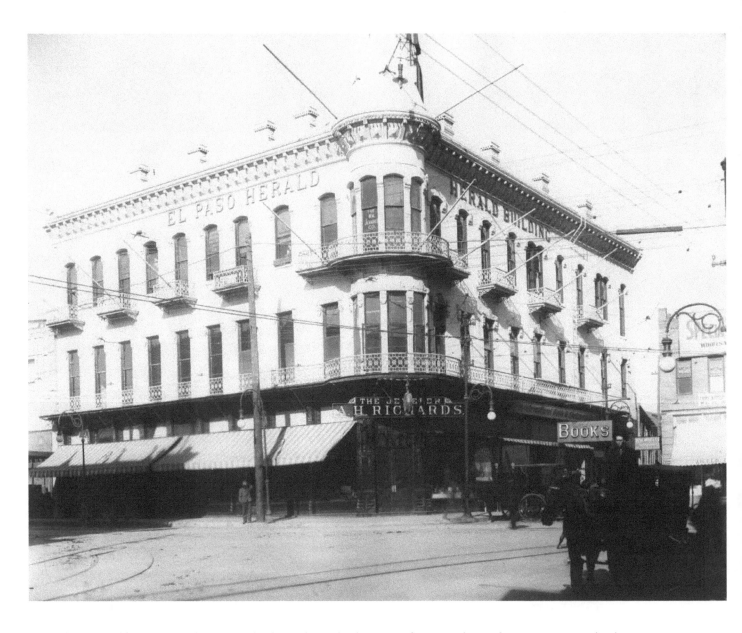

The *El Paso Herald* Building, with A. H. Richards Jeweler in the downstairs front. In a listing for 1903, A. H. Richards was at 103 El Paso Street. The William Jennings Company office was on the third floor, front. On the right side, Felix Martinez had an office upstairs, and the International Book and Stationery Company was downstairs.

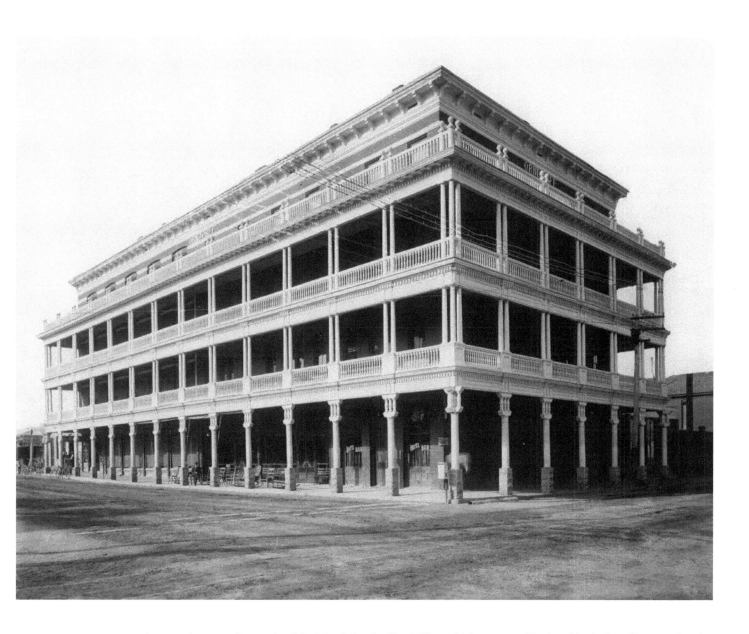

A man relaxes on the porch of the Hotel Orndorff at Mills and Mesa streets. The hotel had a bar, like most hotels. The El Paso Cycle Company, on the left side of the picture, was at 308 Mesa Street and was owned by C. D. Freeman.

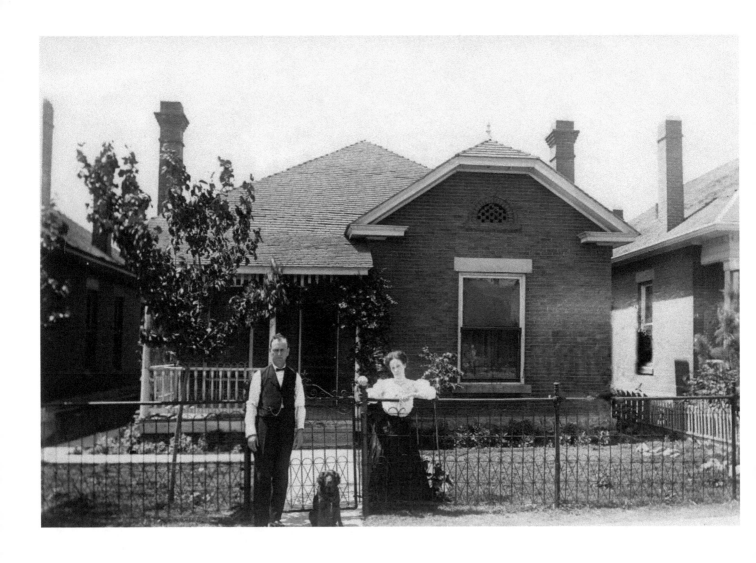

A couple and their dog stand before a bungalow on Campbell Street, which is named for Robert F. Campbell, the mayor of El Paso in 1895-96.

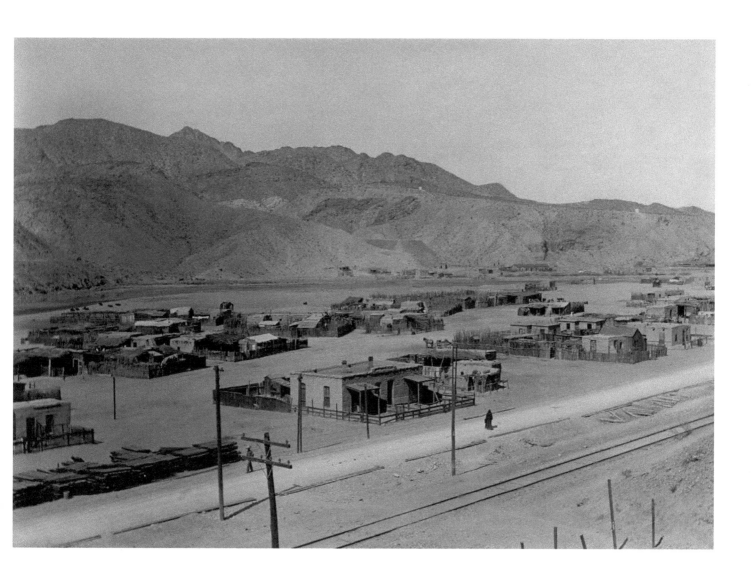

Kansas City Consolidated Smelting and Refining Company built a lead and copper smelter in 1887. Most of the employees were from Chihuahua and lived in houses along the Rio Grande in a community that became known as Smeltertown. They named their church San Rosalia, after a town many of the employees were from. In the 1970s, Smeltertown residents had to move because of lead poisoning, and most of the buildings were torn down.

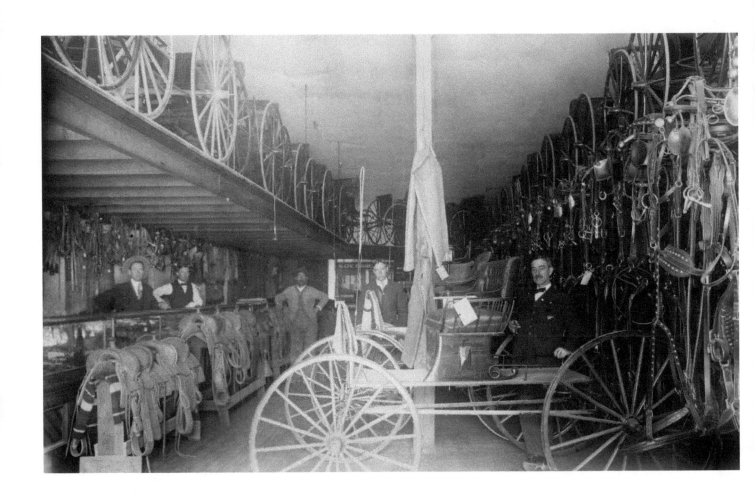

F. C. Cole and H. P. Noake had a carriage and wagon business at the corner of Overland Avenue and Santa Fe Street. Racine Baggage is advertised on the left side of the picture. H. P. Noake manufactured vehicles and harnesses. In Chihuahua, he operated as Noake and DeSmith.

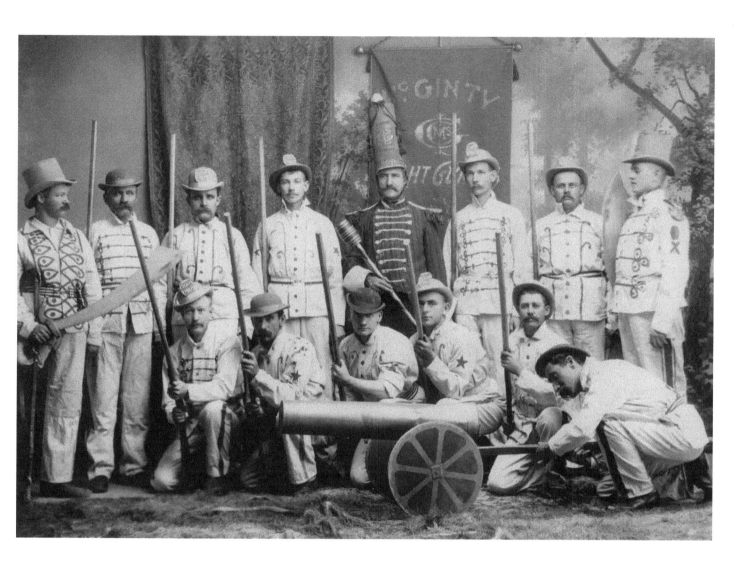

This picture of the McGinty Club Light Guards with their cannon was taken in 1896. The McGinty Club marched in all the El Paso parades and attended every ceremony. In the front row are club members Frank Hughes, Billy O'Brien, Herb Stevenson, Harry Kneeland, Kinney Feathers, and Harry Moss. Standing in the back, from left, are Frederick "Peg" Grandover, Frank G. Gaskey, Henry Ong, Billy Shunman, Captain James J. Longwell, Henry Moore, Thomas Booth, and Jimmy J. Watts.

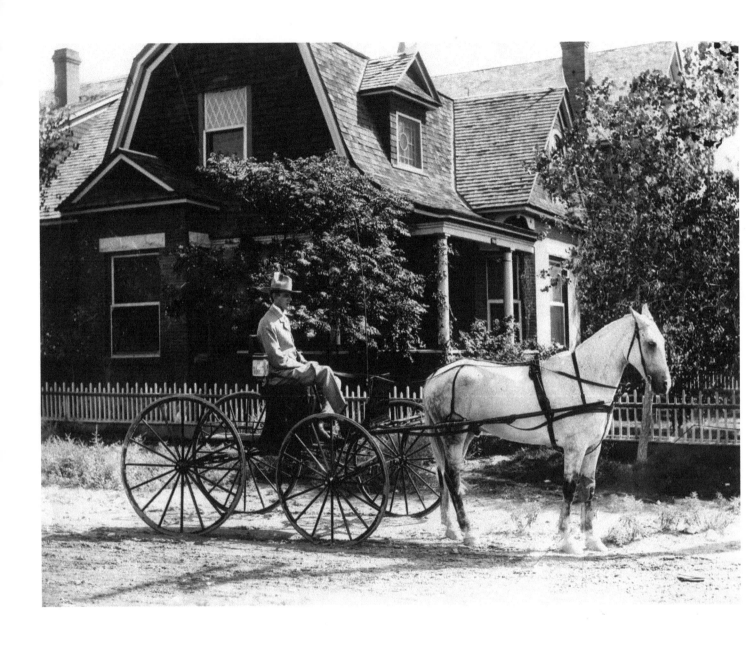

A Tudor-style house, built in 1892. The First Baptist Church, at 805 Montana Avenue, now owns the house.

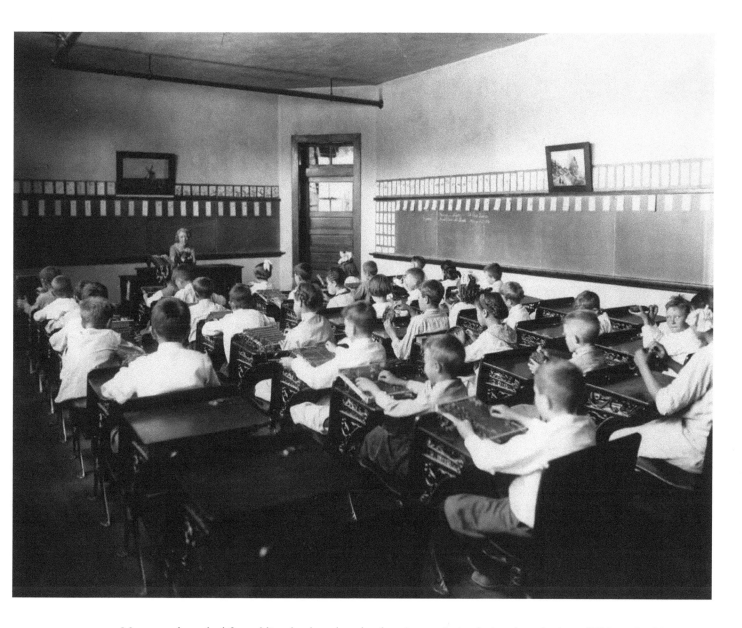

Many people pushed for public schools and made education a priority during the early days of El Paso. In this picture, the students are weaving and making baskets. The date May 1884 is written on the chalkboard. By 1896, El Paso had three private schools and five public ones.

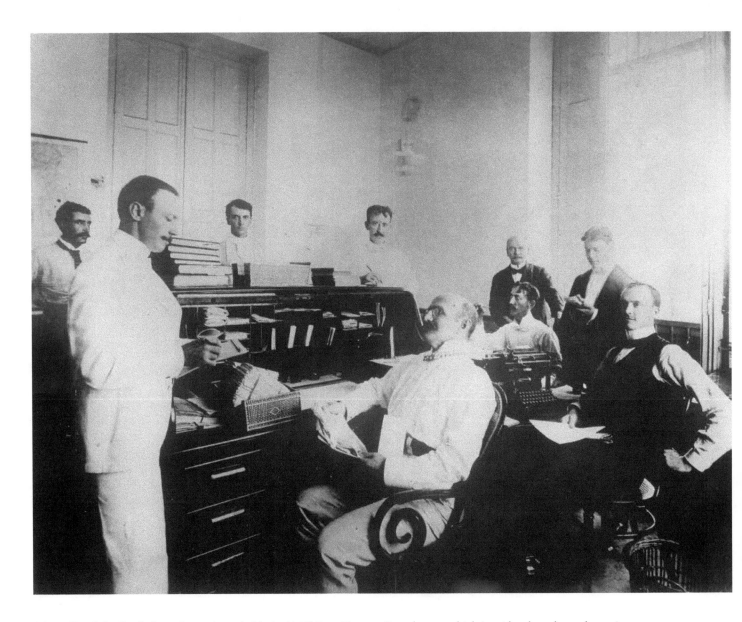

This office full of well-dressed men is probably in the El Paso County Courthouse, which is said to have been the main social and business center for town.

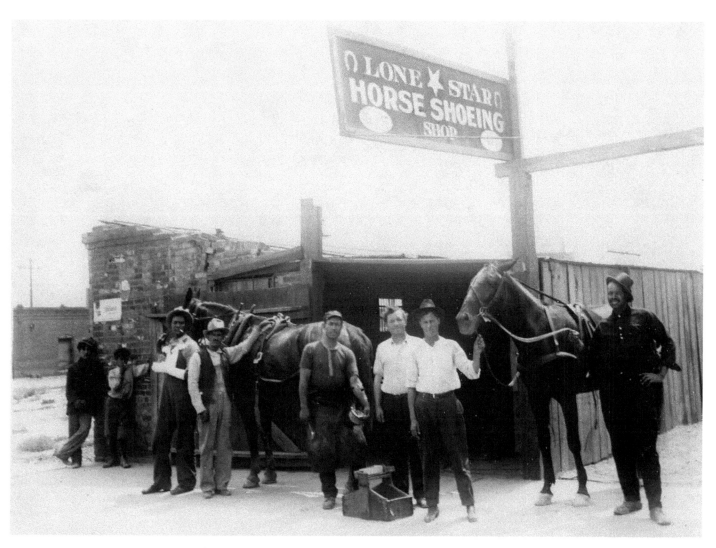

Lone Star Horse Shoeing Shop, with the farrier in the middle of the picture, holding the horse's hoof. Tom Newman is second from right.

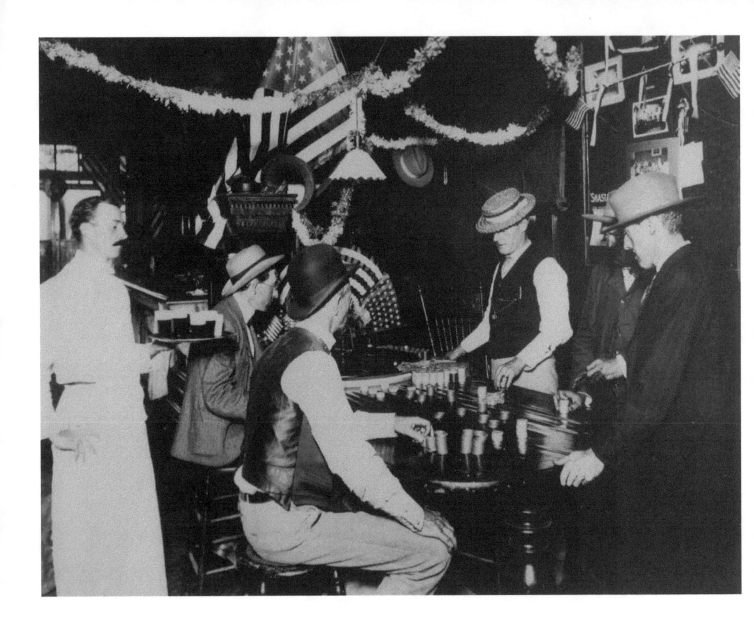

Men gamble at roulette while a waiter brings them beer. A calendar behind them says "Shasta" and "July," and judging by the flags and decorations, the scene may be a 4th of July celebration. Gambling was legal throughout the West at this time.

THE BOOM YEARS

(1900–1909)

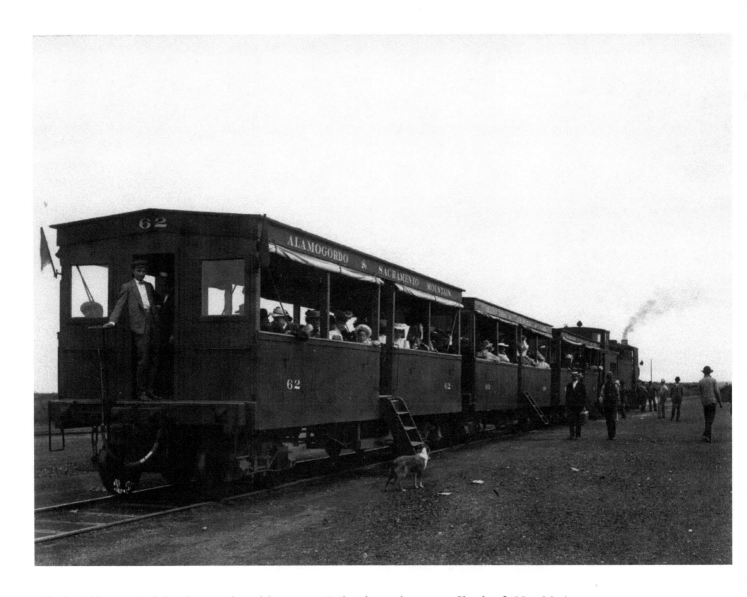

Charles Eddy organized the Alamogordo and Sacramento Railroad to make runs to Cloudcroft, New Mexico, to get timber; but people also rode the Alamogordo and Sacramento Mountain Excursion Train to get away from the summer heat. Many people in El Paso owned cabins in Cloudcroft, and families would spend summers there. Horseback riding was popular in Cloudcroft, and cars weren't very common there until an improved road was built in 1920.

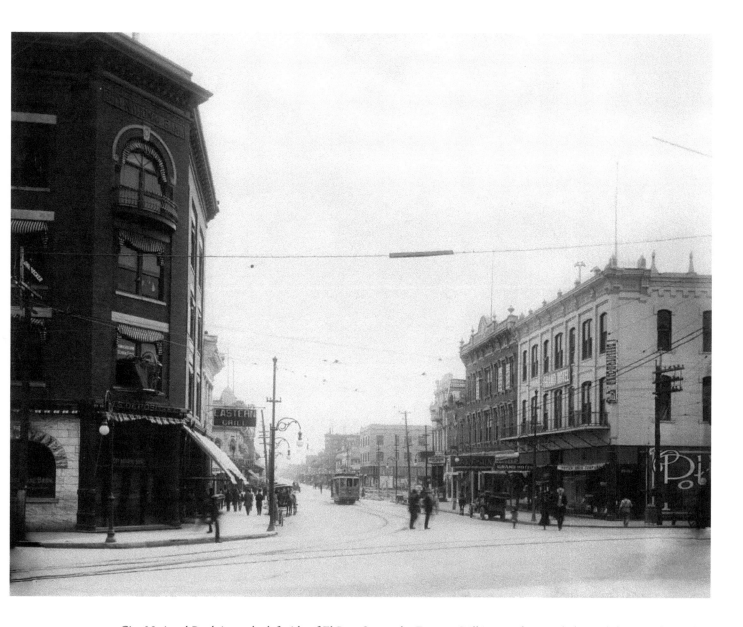

City National Bank is on the left side of El Paso Street, the Eastern Grill is near the streetlight, and the Grand Hotel is across on the right at San Francisco and El Paso. August Andreas was the president and one of the founders of the City National Bank, which was organized in October 1904.

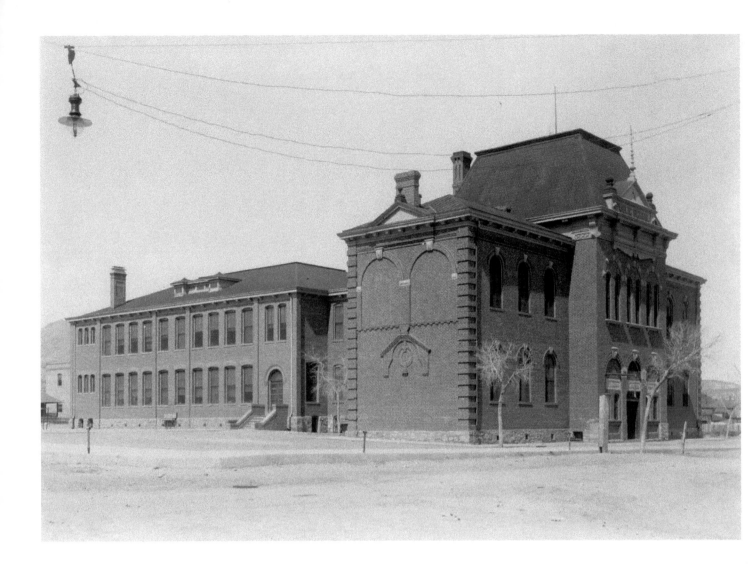

This is the Bailey School, which was built in 1880 and was the oldest public school in El Paso at the time it was closed and torn down in 1945. The Baileys were a prominent family, and one of them was a United States Customs Agent.

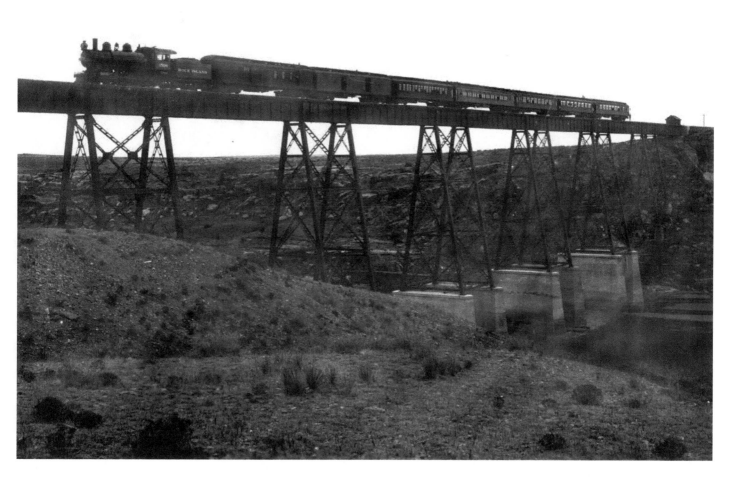

Number 1508, a Rock Island Line transcontinental passenger train, crosses the bridge. The Rock Island and the Southern Pacific jointly operated the Golden State Limited passenger service, starting in 1902. El Paso was connected to the rest of the country and Mexico by many train routes. The city is on the route with the least elevation as it traverses the United States between the East and West coasts.

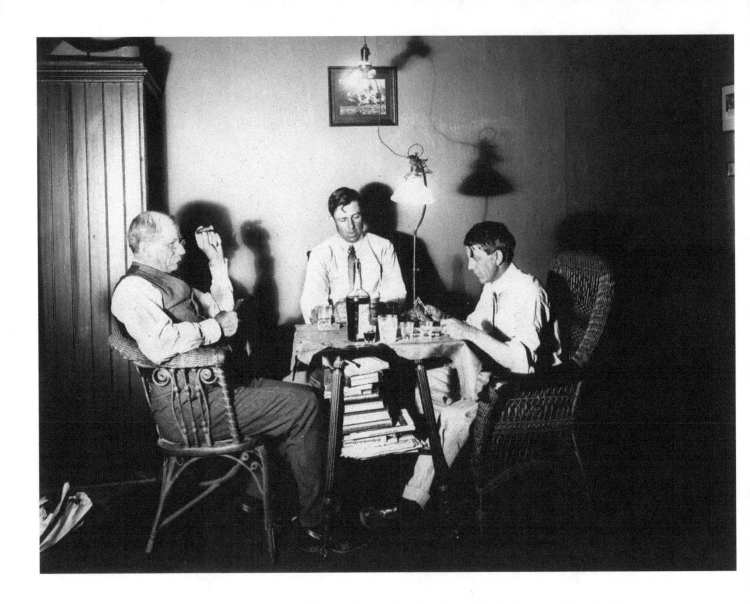

Otis Aultman, the photographer of many pictures in this book, is seated on the right while playing cards. Though titles aren't visible, the reading material under the table includes *Top-Notch Magazine, The Spell of the Yukon* by Robert Service, and the *American Annual of Photography*. Aultman started a club called the Adventurers Club, shortened to the Ad Club, that was an informal group of newsmen, soldiers of fortune, and military men who were in El Paso during the Mexican Revolution and who would get together whenever a few members were in town.

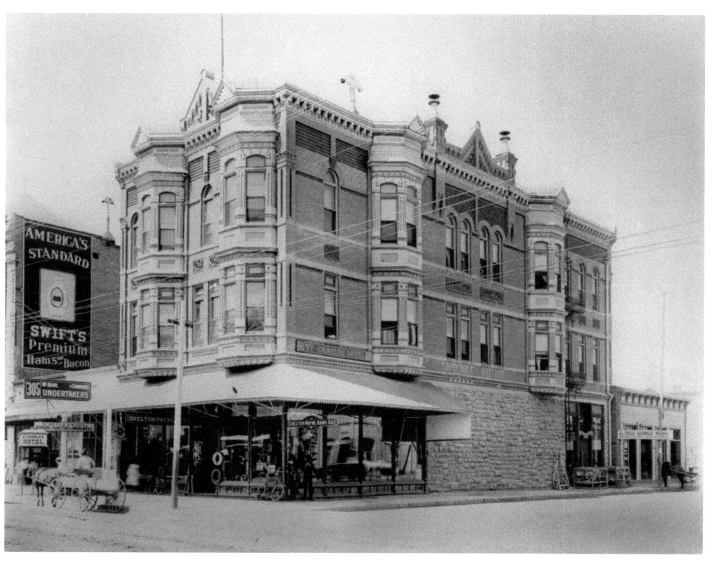

The St. Charles Hotel, upstairs at 301 South El Paso Street, in 1905. The St. Charles Hotel was open until 1996. McBean and Simmons Undertakers is on the left side of the picture, at 305 South El Paso Street, and in the middle of the picture is the Shelton-Payne Arms Company. On the far right side, the El Paso Cornice Works is at 106 West Overland Avenue.

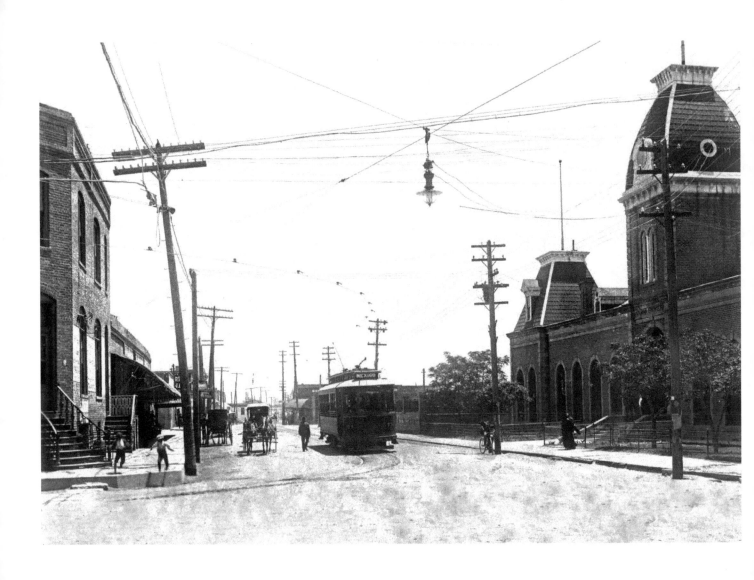

Avenida 16 de Septiembre, with the Ciudad Juárez Customs House on the right. The El Paso Street Railway Company started in 1882, with mules pulling the streetcars. In 1902 the streetcars switched to electric, and Mandy the mule was given a ride on a flatcar to celebrate her retirement. The electric streetcars connected El Paso, Juárez, and Fort Bliss.

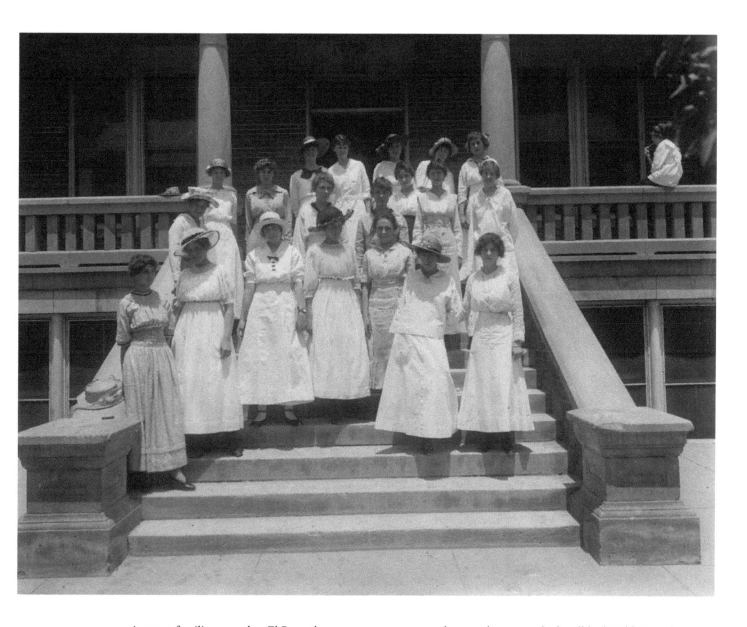

As more families moved to El Paso, there were movements to clean up the town, which still had Wild West elements. Among the local organizations, the Woman's Club of El Paso was organized in 1894 and worked tirelessly to improve the city, while a local chapter of the Women's Christian Temperance Union was organized in 1896.

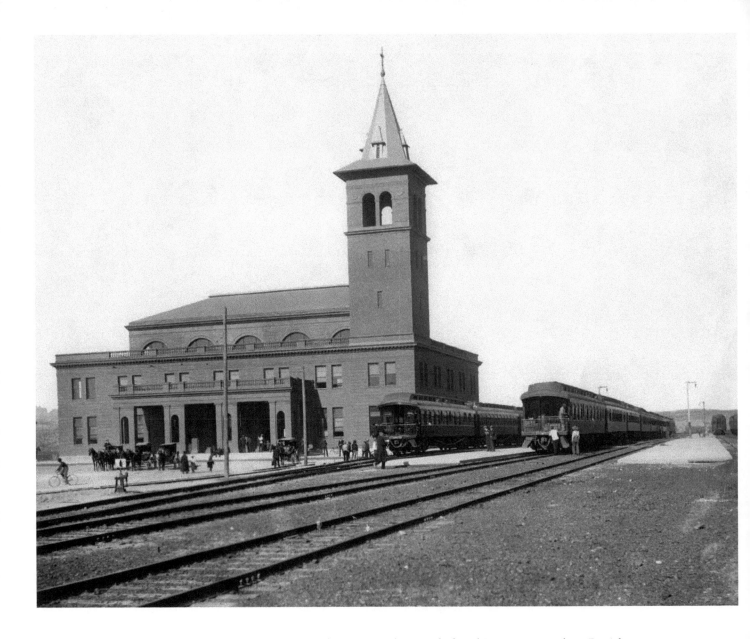

Union Depot opened at 700 San Francisco Street on March 1, 1906, only a year before this picture was taken. Daniel Burnham, the architect, designed the depot to replace the seven different stations used by various railroads. The red brick, neoclassical building has been restored and is now on the National Register of Historic Places. Pancho Villa is said to have used the tower of the depot as a lookout during the Mexican Revolution.

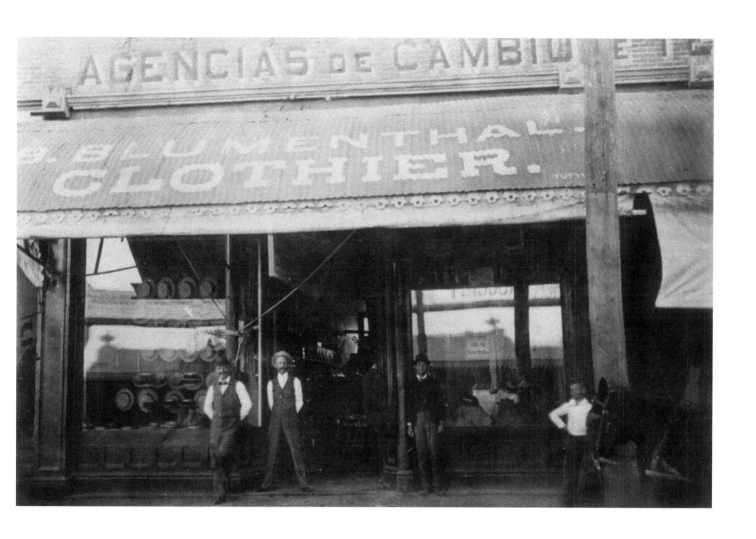

Agencias de Cambio and Blumenthal Clothier was owned by Bernard and Adolph Blumenthal at 117 South El Paso Street. It was established in 1892. Two of the men in the picture—probably the two on the left—are Bernard Blumenthal and Park W. Pittman. They changed currency and sold clothes.

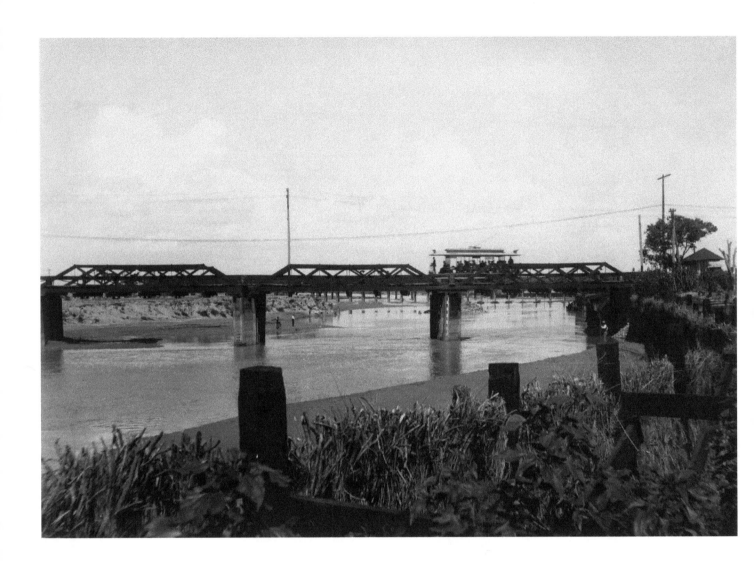

With old wooden bridge pilings in the foreground, people can be seen on the riverbanks below as a trolley crosses the Santa Fe Street International Bridge.

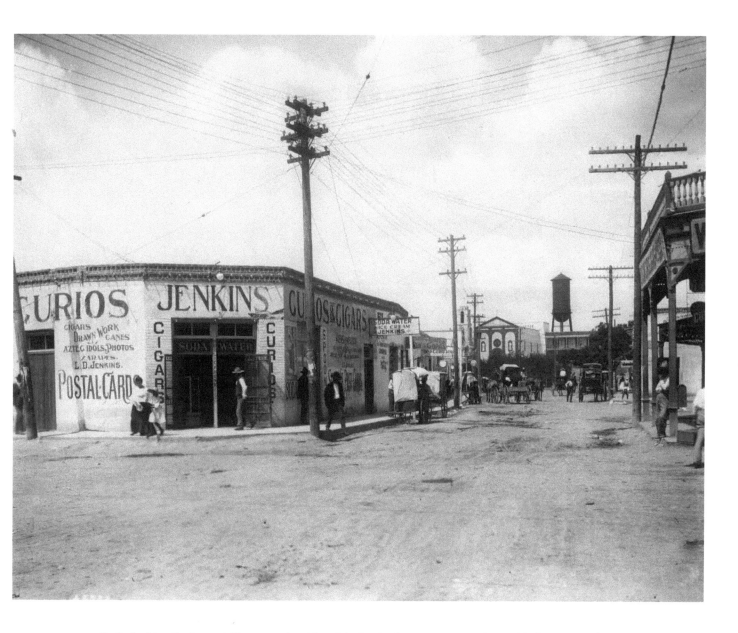

L. D. Jenkins Curios and Cigars, on Avenida 16 de Septiembre, in Juárez. Jenkins sold photos, postal cards, curios, cigars, canes, drawings, shoes, cut coins, jewelry, and old relics. Our Lady of Guadalupe Church can be seen in the background.

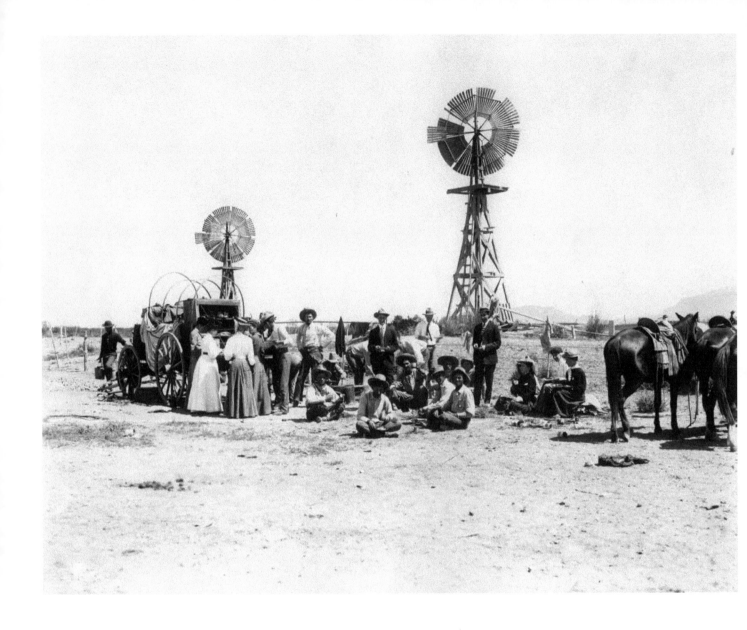

A cattle ranch picnic, with a chuck wagon, plenty of food, cowboys with tin plates and cups, and well-dressed ladies and gentlemen. Ranching and agriculture were the region's main businesses after 1827, when Juan María Ponce de León built his ranch. In 1849, Ponce de León sold the ranch to Benjamin Franklin Coons. Coons built a general store, and the settlement became known as Franklin.

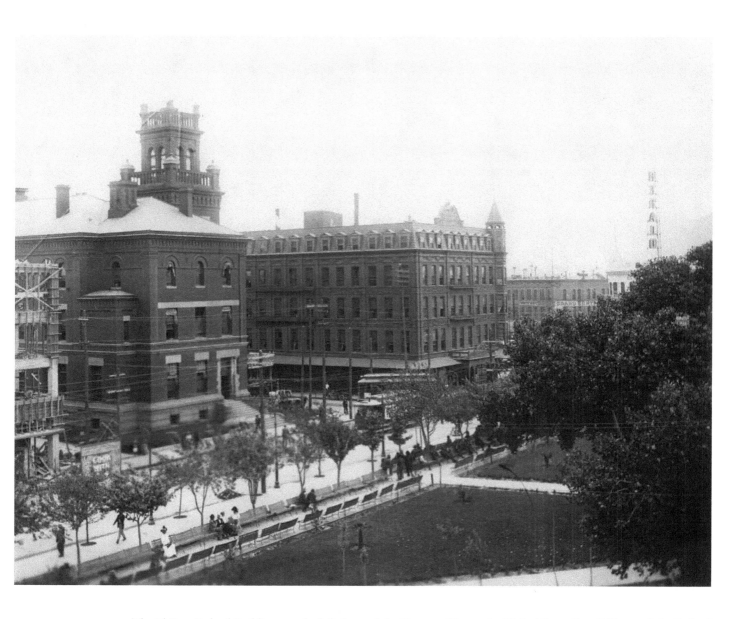

The El Paso Federal Building, on the left, housed the Customs House, the United States Post Office, and the Federal Courthouse. Hotel Sheldon, in the center, was managed by Burt Orndorff. The Grand Central Hotel is on the right, and San Jacinto Plaza in the foreground, with people enjoying a rest on the benches. Fisher Satterthwaite designed the park. He constructed the fence and gazebo, planted elm trees, and created a pond in which alligators were kept.

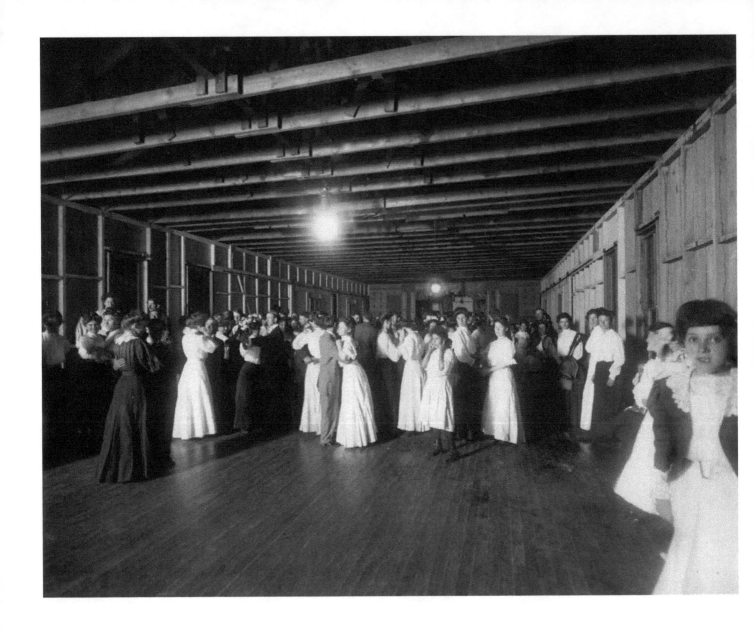

Cloudcroft Lodge was built in 1901 to accommodate mountain vacationers, some of whom are perhaps at a dance here to celebrate summer. In 1909 the lodge was destroyed by fire.

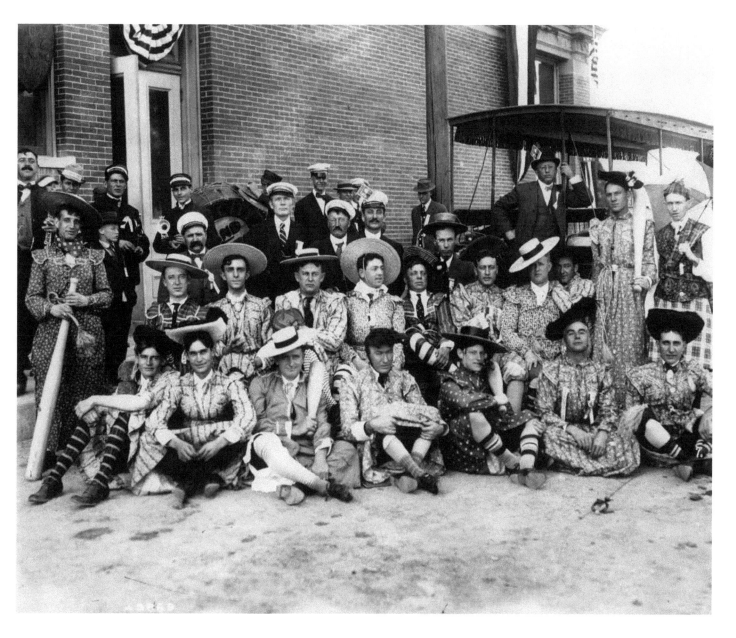

Among this festive group, some dressed in women's clothing, hatbands have the words "Commercial Travelers, October 7, 1904, Albuquerque." Like Albuquerque, El Paso had a Commercial Club for promoting business. Many such clubs held conventions in El Paso, which had ready access to gambling after most cities in the United States made gambling illegal.

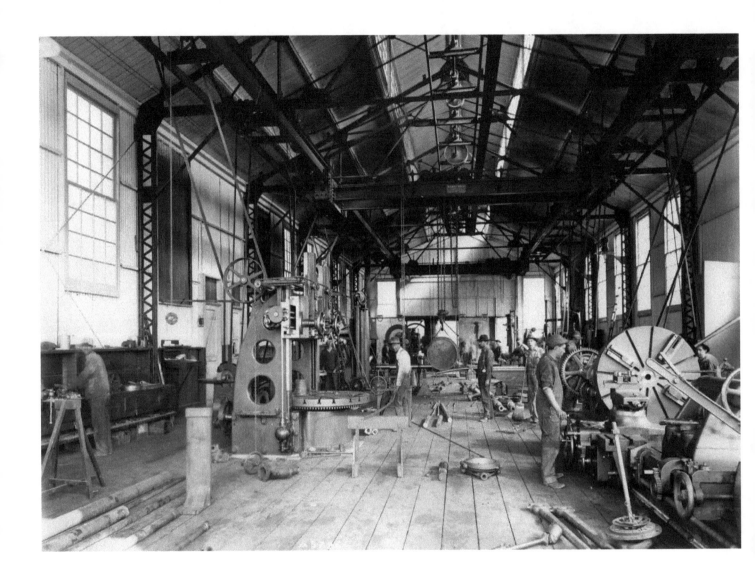

Mining was a major industry in El Paso and provided work of all sorts. This machine shop has a large metal lathe, seen on the right.

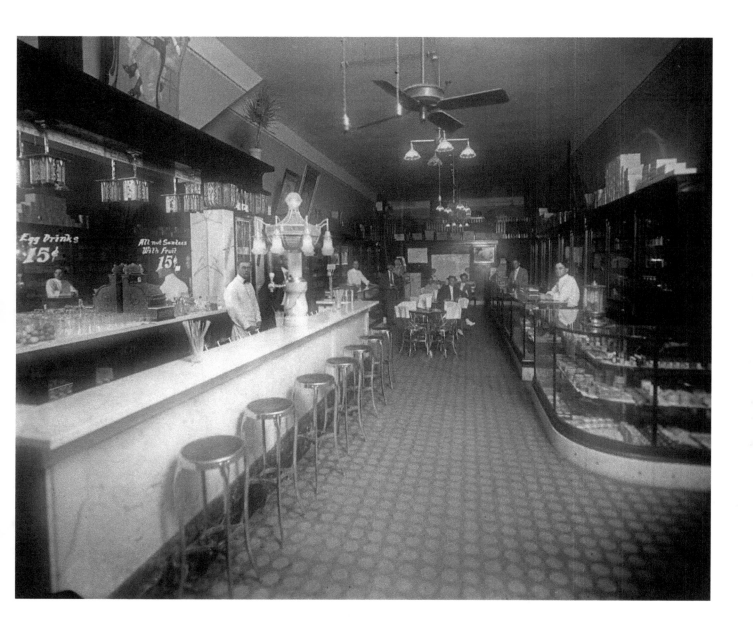

Potter and White Drug Store, 4 Plaza Block, with egg drinks for 15 cents and nut-and-fruit sundaes for the same price. Egg drinks were mixed with milk or malted milk and were served at soda fountains in the days before ice cream shakes. In 1903, El Paso had twelve drugstores.

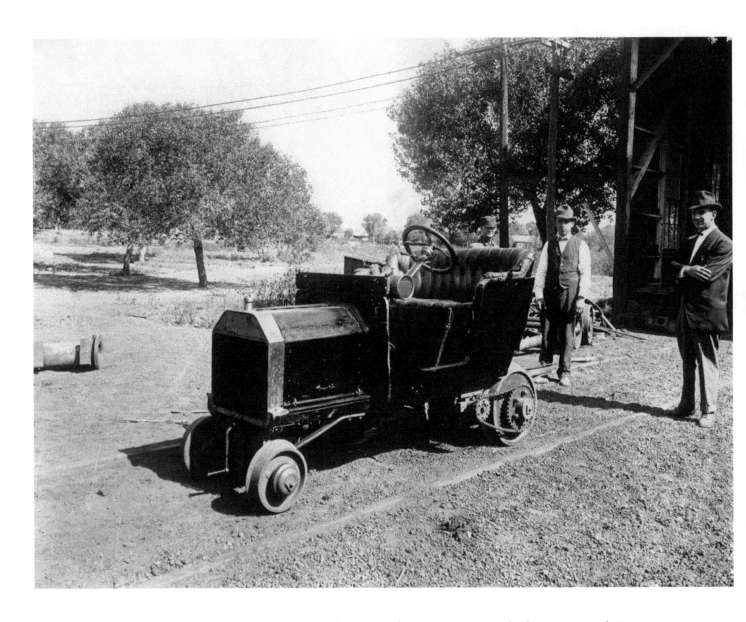

An early Ford vehicle modified for operating on mine rails. El Paso was a big mining center, with silver, copper, and zinc coming into the United States from mines in Mexico, and coal being exported to Mexico. About 3,000 people worked in the custom smelter in El Paso. People and companies involved in the mining industry would come into town to buy supplies, equipment, and materials.

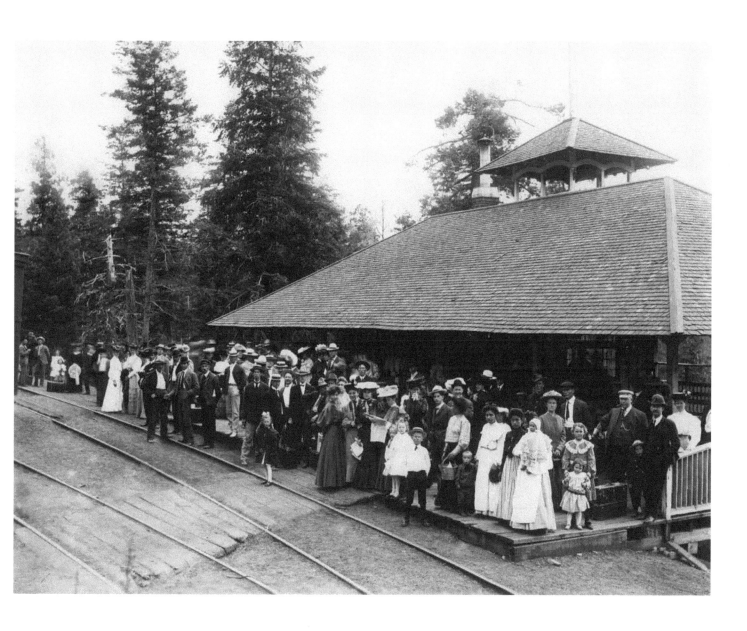

A crowd waits at the Cloudcroft Train Station for passage back to El Paso. The El Paso Woman's Club, Dr. Herbert Stevenson, Joshua Raynolds, the Little Theater Group, and many others helped raise funds to open the Baby Sanitarium in Cloudcroft. Many children in El Paso became sick from heat-related problems in the summers and were sent to the Cloudcroft Baby Sanitarium for its fresh air and for the benefit of their health in general.

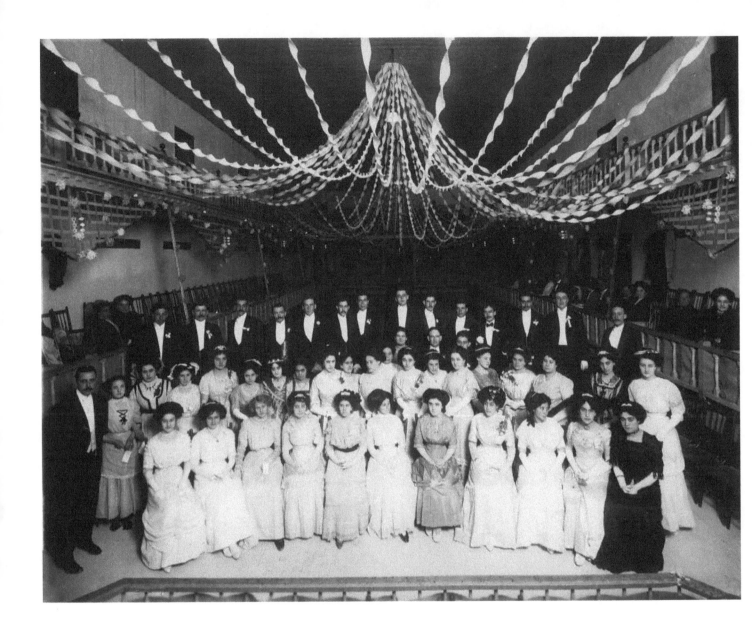

This group of men and women in formal clothing may have gathered for a Quinceañera, the celebration of a girl's fifteenth birthday, when she becomes a woman. This rite of passage is still celebrated today and can be a party at home or a more extravagant production.

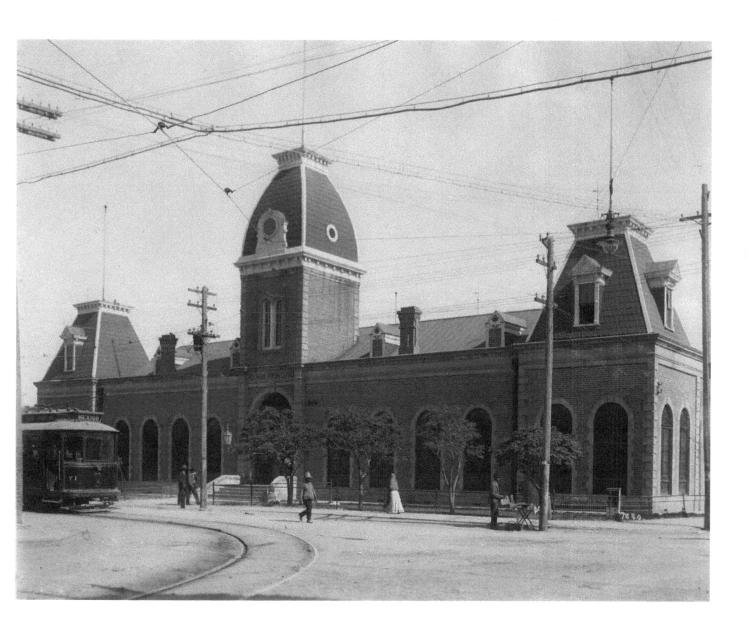

Aduana Fronteriza, the Ciudad Juárez Customs House, built during the years 1885 to 1889. This Victorian building was where all the merchandise crossing the border was taxed. Railroads carried goods back and forth between the United States and Mexico, but the tracks seen here were for the trolley line that ran between the two countries.

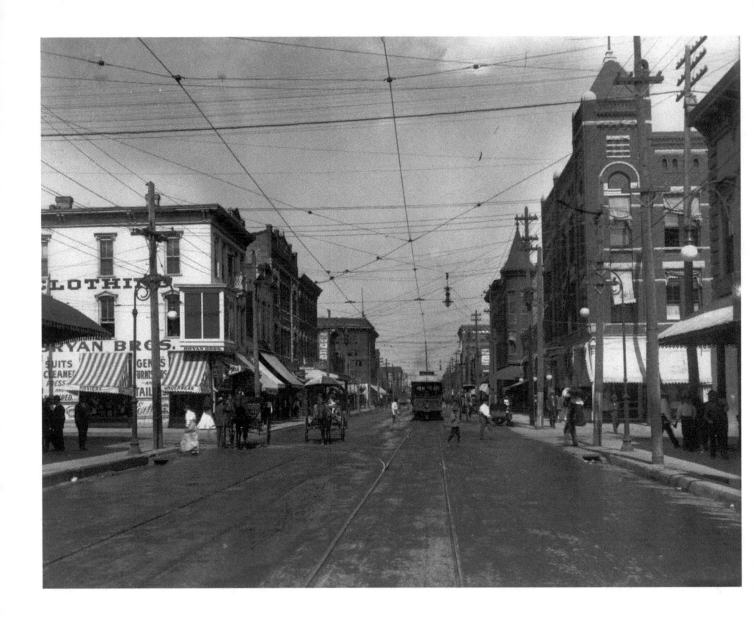

Bryan Bros. Clothing, on the left, was at 320 San Antonio Avenue, with the Palace Theatre beside it. Husselman and Jenkins sold cigars and had pool tables at 322 San Antonio. Elsewhere on the street, the Caples Hotel was run by Mrs. J. F. Crews, while the Silver King Restaurant and Bar had Carl Kirchner as the proprietor. Seen here on the right is the Fred J. Feldman Company, which sold photographic and engineers supplies at 308 San Antonio after moving from 111 El Paso Street.

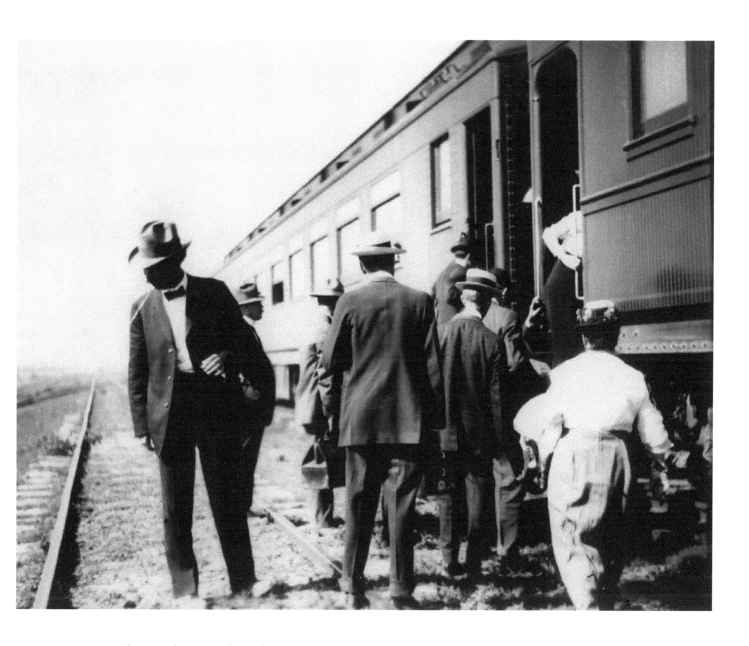

When people visited El Paso for important events, they came on the train and dressed up for the journey. Travelers from all over the United States and Mexico came to El Paso and Juárez in 1909 to greet the two countries' presidents and witness their historic meeting.

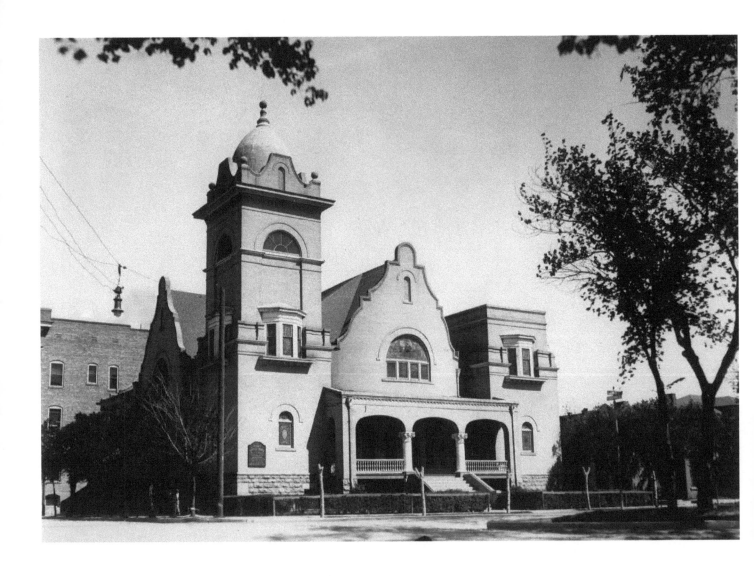

First Baptist Church, at 801 Magoffin Avenue. The street is named after Joseph Magoffin, who built the Magoffin Homestead in 1875 and was elected mayor in 1881. Many nice residences were built in the Magoffin Addition in the 1880s.

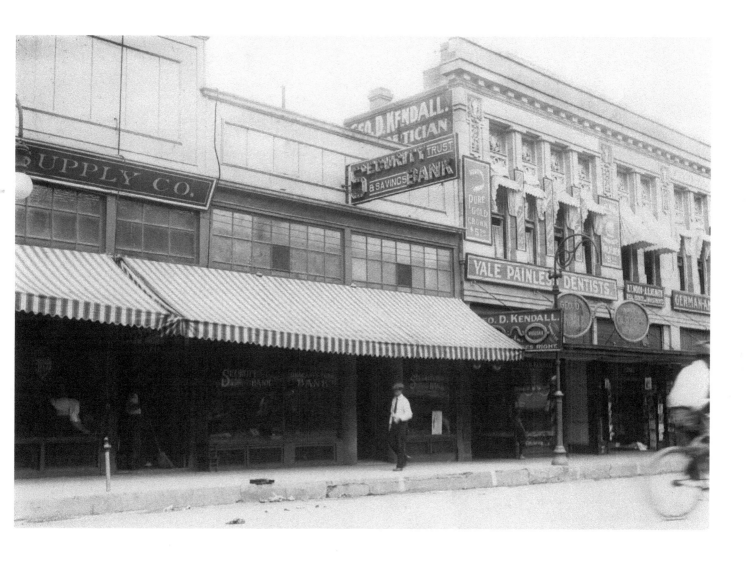

The Security Trust and Savings Bank, on Mills Street. Next door is the George D. Kendall Optical Company, with Yale Painless Dentists upstairs. A pure gold crown cost five dollars!

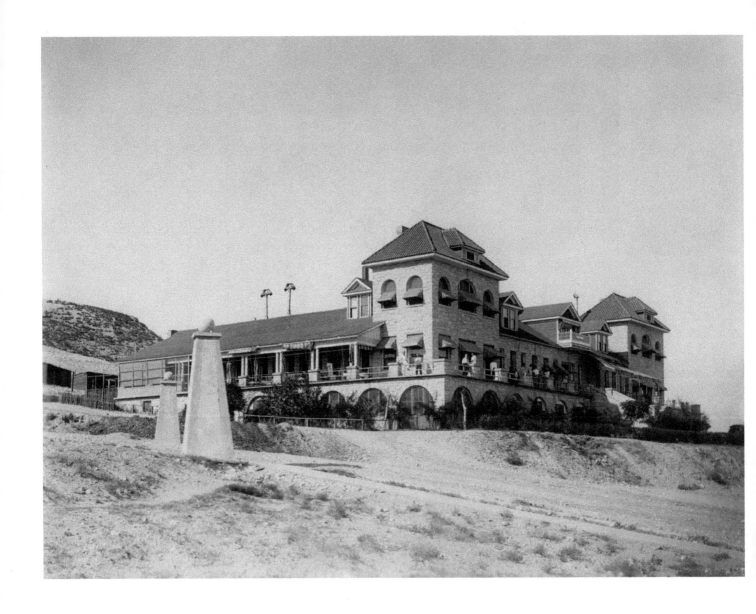

St. Joseph's Hospital, or St. Joseph's Sanatorium, was at 190 Grandview Avenue. Lured by the abundant sunshine, many people moved to the Southwest to cure tuberculosis and other lung problems. El Paso promotions at the time said the city spent $200,000 a year for health conservation and sanitation.

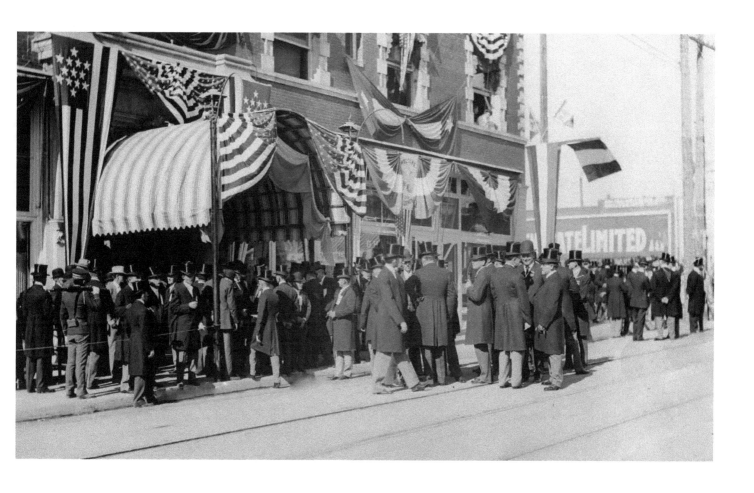

President William Taft was in El Paso on October 16, 1909, to meet with President Porfirio Díaz of Mexico. A presidential breakfast was held for Taft at the St. Regis Hotel, on Oregon Street. Afterward, the president went to the Chamber of Commerce.

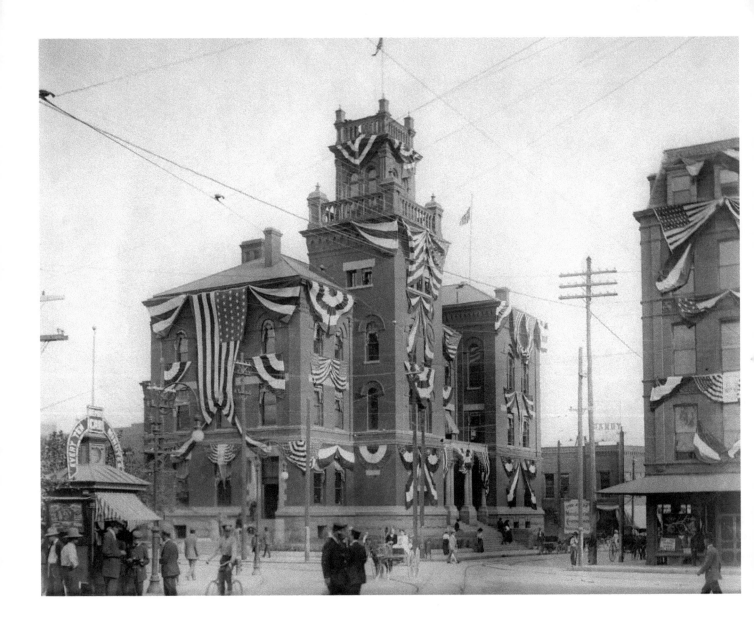

On October 16, 1909, the El Paso Federal Building, at the corner of Mills and Oregon streets, was decorated and ready for the historic meeting between presidents William Taft and Porfirio Díaz. The low-flung building behind the poles is the Elite Manufacturing and Confectioners; Pancho Villa held meetings there, and it was his favorite place for a strawberry soda.

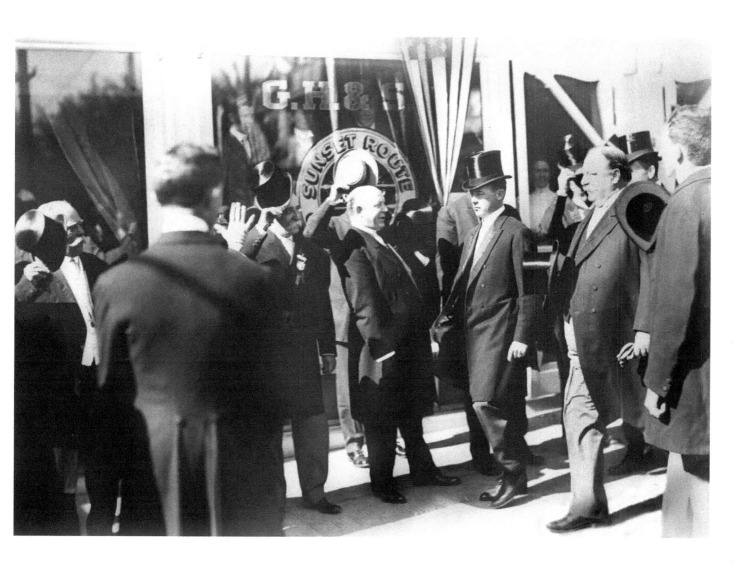

El Paso went all-out on the occasion of the Taft-Díaz meeting, with townsmen donning silk top hats and Prince Albert coats. The two presidents met at the center of the International Bridge and were taken in carriages through El Paso with the United States Army Cavalrymen and the Mexican Army as escorts.

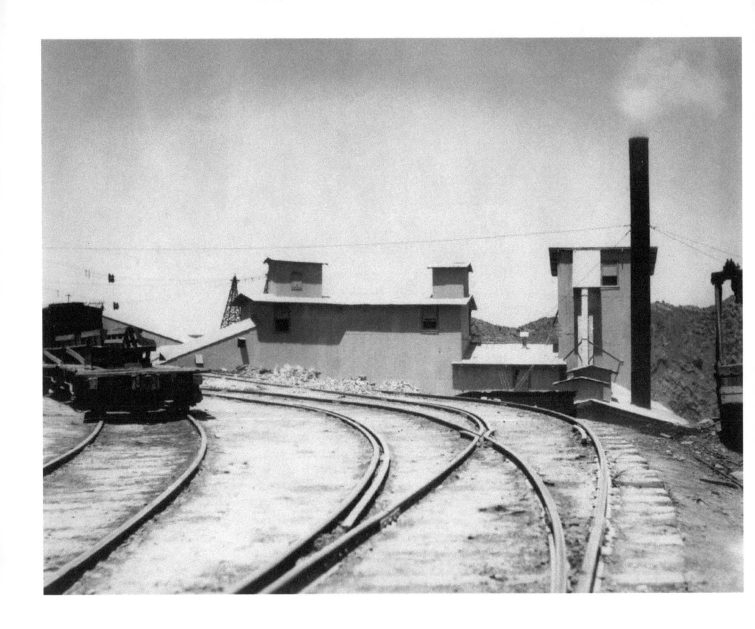

El Paso advertised itself as the Gate City, the commercial center of the Southwest. The chief business interests were the mining and smelting of gold, silver, lead, and copper ores. The El Paso Smelting Works employed 1,200 people at this time.

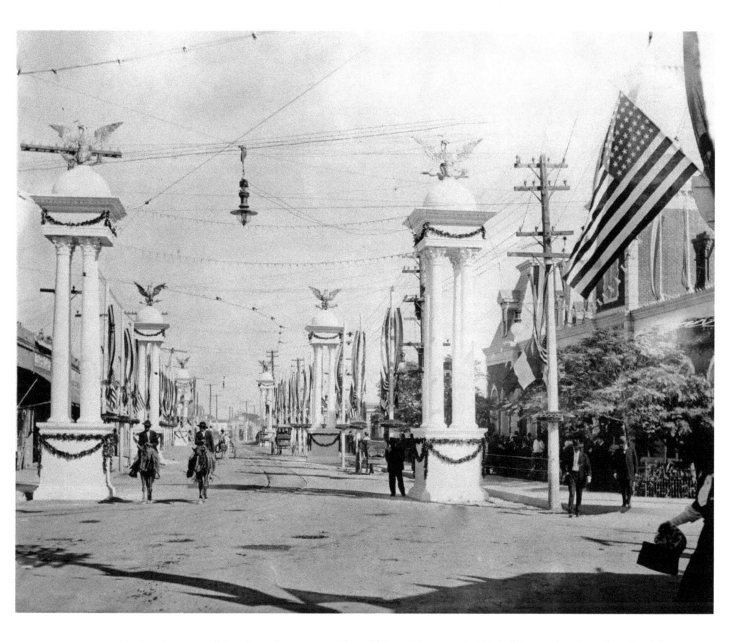

In the afternoon of October 16, 1909, presidents Taft and Díaz met in Ciudad Juárez. On the right side of this picture is the Juárez Customs House, at Avenida Juárez and Avenida 16 de Septiembre. The Victorian building was restored in 1990 for the Juárez Museum of History.

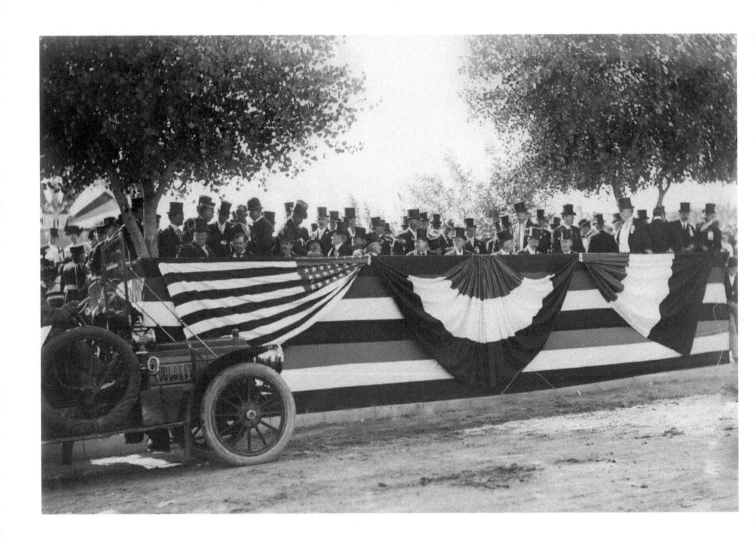

The United States Delegation is in the reviewing stand for the Taft-Díaz meeting, October 16, 1909.

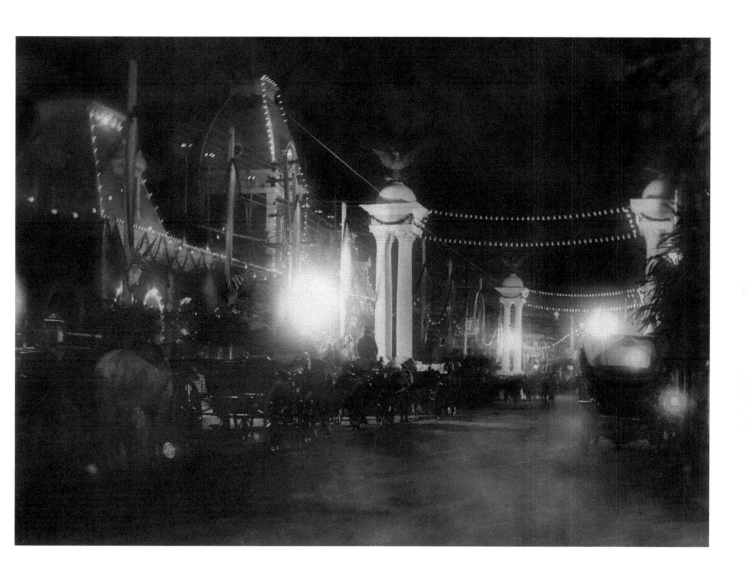

The Juárez Customs House the night of the Taft-Díaz meeting, October 16, 1909. The building was decorated as a Versailles salon with red curtains, pictures of George Washington and Miguel Hidalgo, fine linen, gold and silver Maximilian silverware, and cut crystal. Felix Martinez, of El Paso, gave the presidents gold goblets from his city.

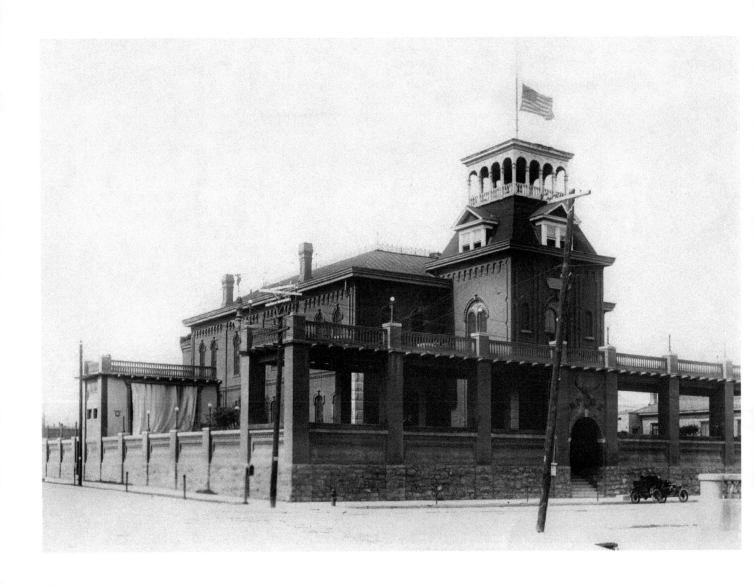

Elks Club, El Paso Lodge 187, Benevolent and Protective Order of Elks. Formerly El Paso's first school building, the Central School, it stood on the corner of Myrtle Avenue and Campbell Street and was built by Bernard and Benjamin Schuster. The building was torn down, and a new Elks Club was built at the same location.

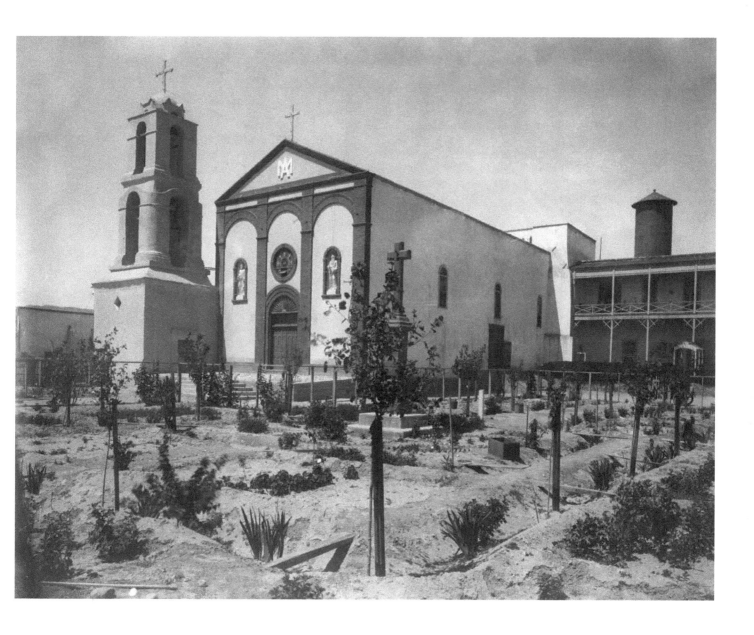

The adobe Mission of Our Lady of Guadalupe (Mission Nuestra Señora de Guadalupe) was inaugurated on January 5, 1662. It was an important stop on El Camino Real de Tierra Adentro, the Royal Road to the Interior. During the 1680 Pueblo Revolt in New Mexico, refugees went south and sought shelter at the mission. The church still stands and has been restored, using the original sketches.

The box canyon near Ojo Caliente is an archaeological site that spans 900 years. The area was occupied by the ancient Anasazi and Mogollon cultures and later was home to Chief Victorio of the Mimbres band, the Warm Springs Apaches. The area was called La Canada Alamosa, then was changed to Monticello Canyon in 1881. The small creek is Alamosa Creek. To the right of the wagon, photographer Otis Aultman can be seen setting up his camera.

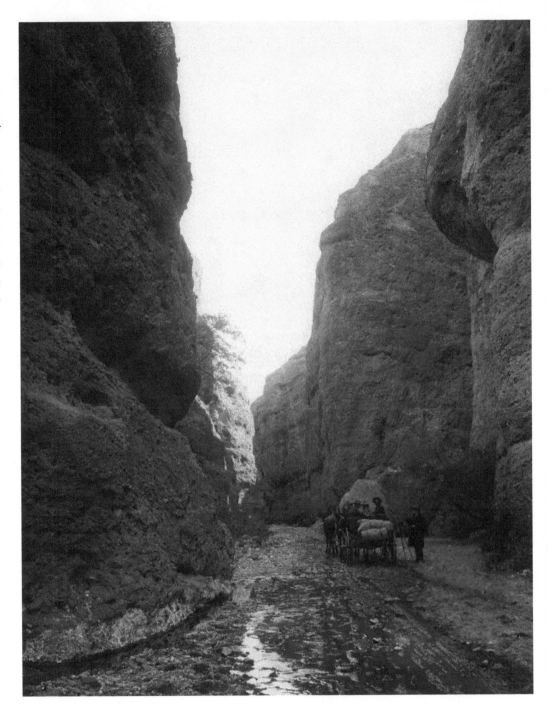

THE MEXICAN REVOLUTION AND WORLD WAR I

(1910–1919)

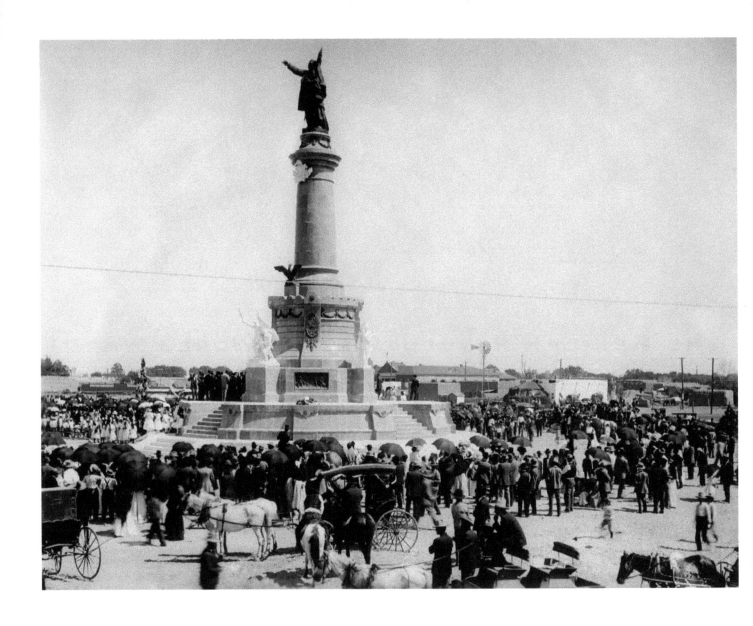

The September 16, 1910, inauguration of the Monumento a Benito Juárez (Benito Juárez Monument) in Ciudad Juárez, Mexico, celebrated a century of independence from Spain. Governor Enrique Creel of Chihuahua commissioned Italian sculptors Fransisci Rigalt and Augusto Volpi to oversee the marble project. The monument's four plaques represent the life of Benito Juárez. Mexico declared independence from Spain on September 16, 1810.

An early automobile carries a pair of newsmen up a hill. Newsmen from all over the United States followed the troops during the Mexican Revolution.

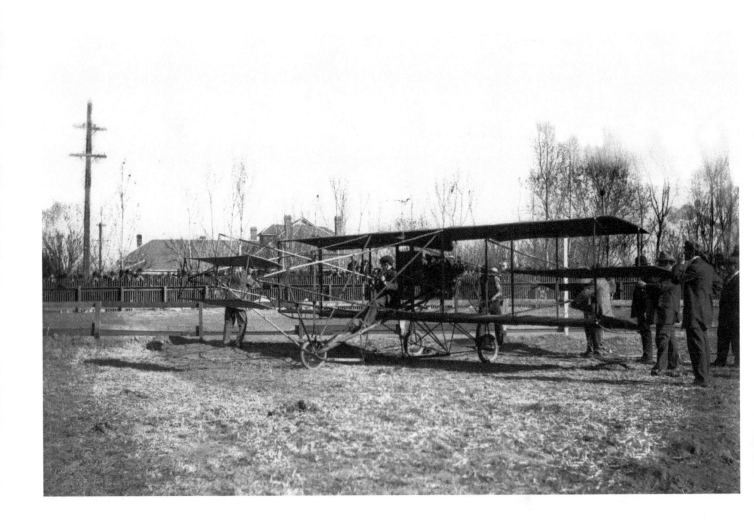

Charles Hamilton, known as the Birdman, learned to fly from Glenn Curtiss. In 1910 he did exhibition flights in Tucson and Douglass, Arizona, then came to El Paso and was photographed here at Washington Park. The park is an enjoyable place where many events are still held.

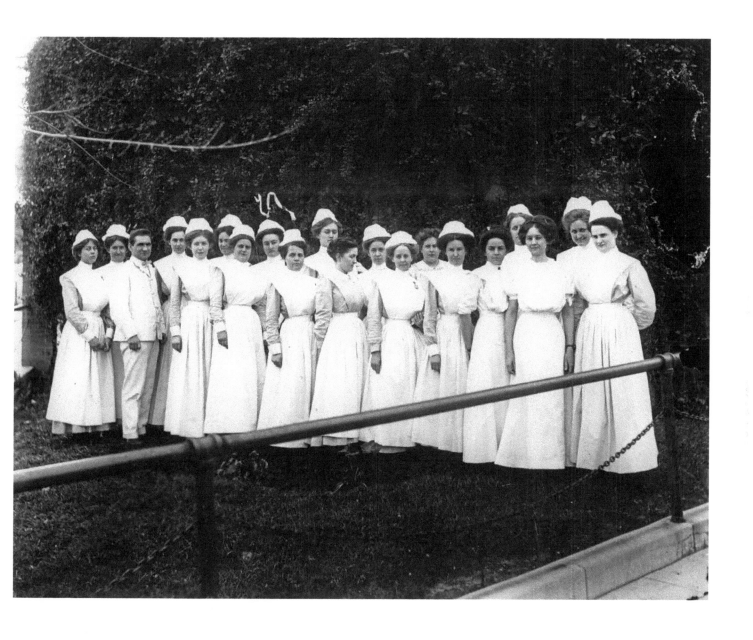

El Paso, like most cities in the Southwest, advertised itself as a health center and always needed nurses. This group is the Providence School of Nursing class of 1912.

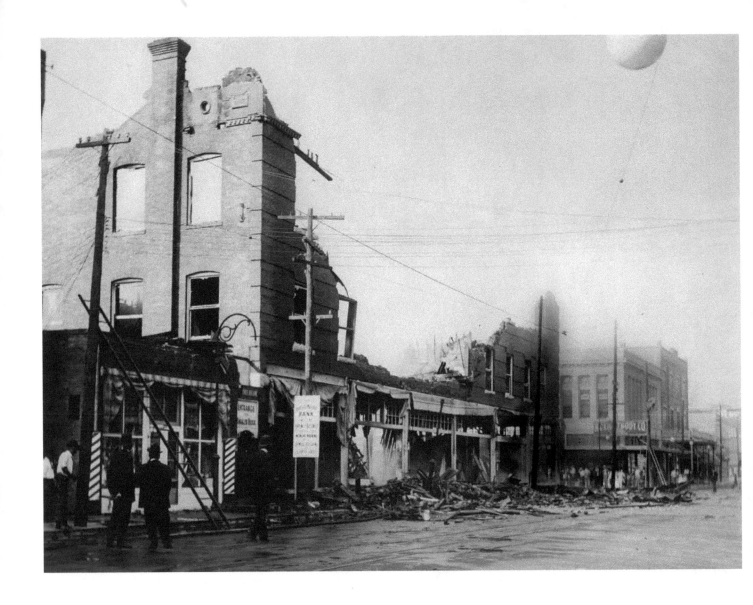

This fire-gutted shell of a three-story building was a reminder of the dangers of fire in El Paso's dry climate. The sign near the building says "American National Bank will be open for business." In 1905, the Myar Opera House caught fire and the whole block was destroyed. One of the reasons the architect Henry C. Trost was in demand was his use of concrete, which is fire resistant. The odd-looking sphere at upper-right is the globe of a streetlamp.

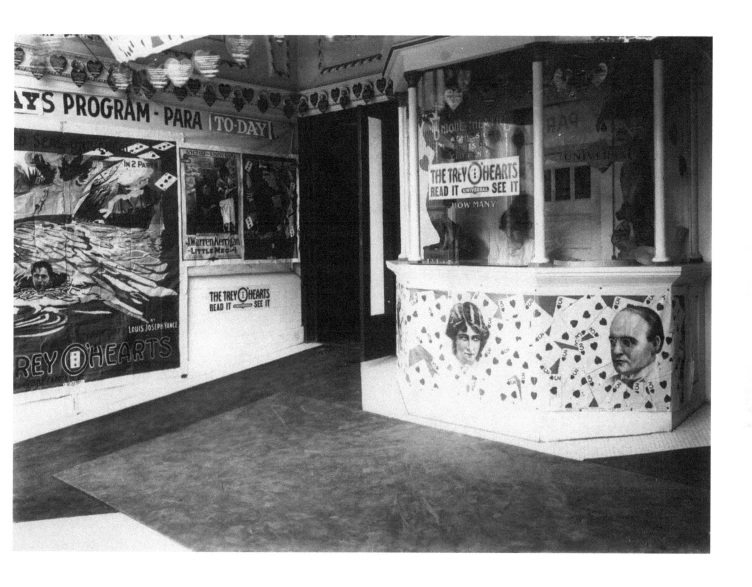

Tickets to see *Trey O'Hearts* at the Unique Theatre cost 10 cents for adults and 5 cents for children. Released in 1914 by the Universal Film Manufacturing Company, *Trey O'Hearts* was a 15-episode serial based on a novel by Louis Joseph Vance.

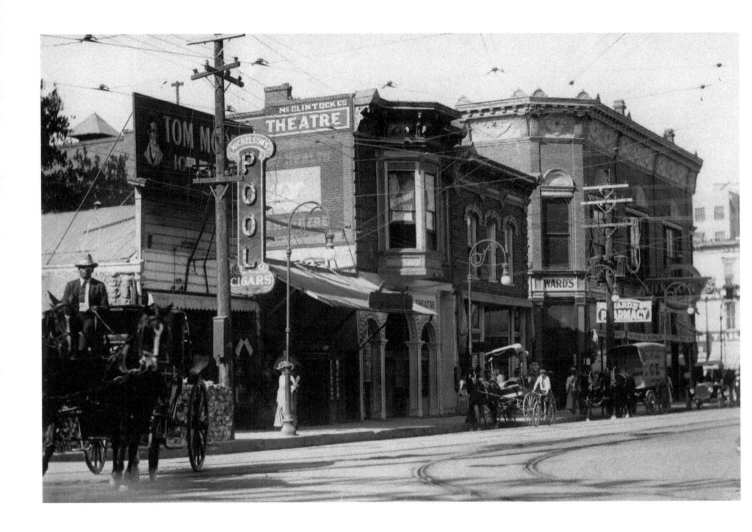

The Crystal Theatre, in the 100 block of East San Antonio Avenue, flanked by Michelson's Pool and Cigars and Ward's Pharmacy on the right side of the picture. W. T. Hixson Jewelers is on the far right, at 111 San Antonio Avenue.

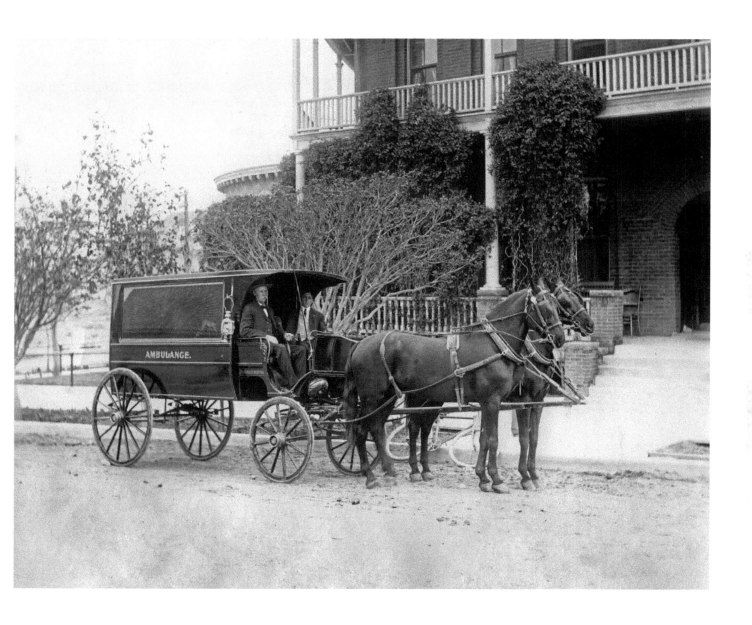

Providence Hospital opened in 1902 at Upson Avenue and North Santa Fe Street. The horse-drawn ambulance of the firm McBean, Simmons, and Carr is seen here in front of the old Providence Hospital in 1910, with Mr. McBean holding the reins. The hospital advertised its beneficial location in the fresh air away from the noise of the city. The Providence staff was supervised by Miss M. R. Shaver.

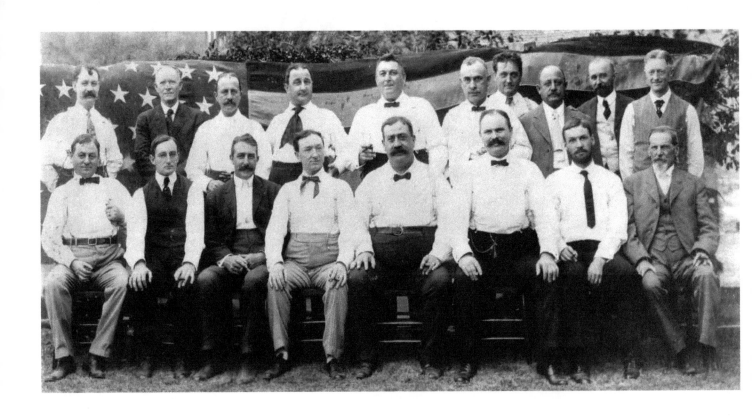

The El Paso Chamber of Commerce, front row: Jim Watts, unidentified, George Squires, Jack Keevil, Dan W. Reckhart, William McCoy, Doc Dengler, unidentified; second row: George Ogden, C. E. Kelly, Louis Behr, Anton Van Mourick, Crawford Harvie, W. T. Hixson, Will R. Brown, Frank Behr, two unidentified.

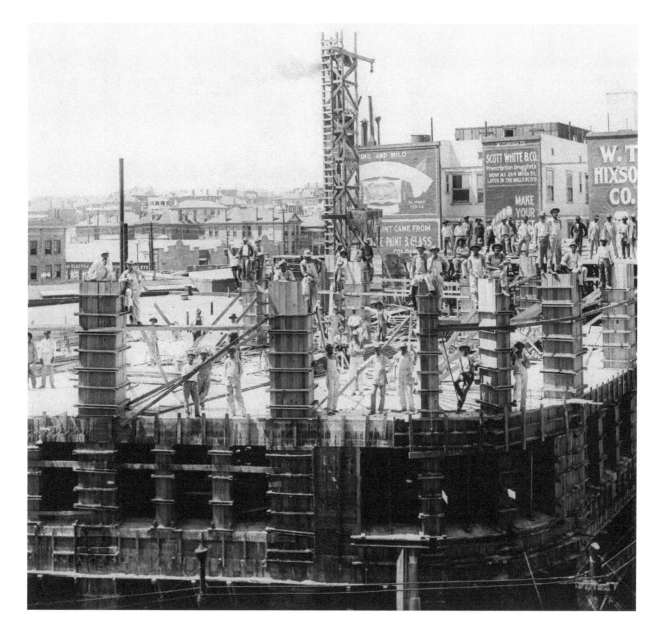

At the construction site for the White House Department Store and Hotel McCoy, at 127 Pioneer Plaza, the construction crew pose near their wooden forms for pouring concrete. Behind them are signs for Tuttle Paint and Glass, on North Stanton Street; Scott White and Company Drugs, on Mills Street; and W. T. Hixson Company Jewelry, at Mesa and Mills. The store building is now the Centre, at 123 Pioneer Plaza, and is on the National Register of Historic Places.

Seen here in 1911, the Posener Building, also known as Little Caples Building, was designed by architect Henry C. Trost and housed the Max Posener Millinery business at Mesa and San Antonio Avenue. The Posener Building was demolished in 1941.

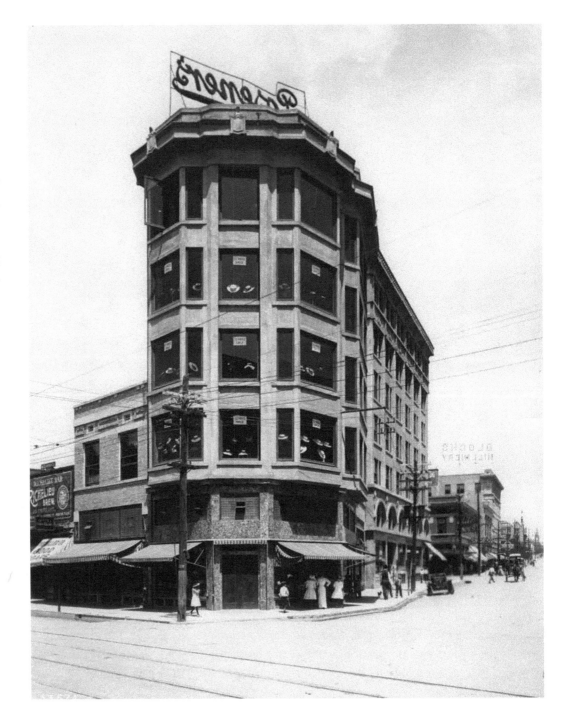

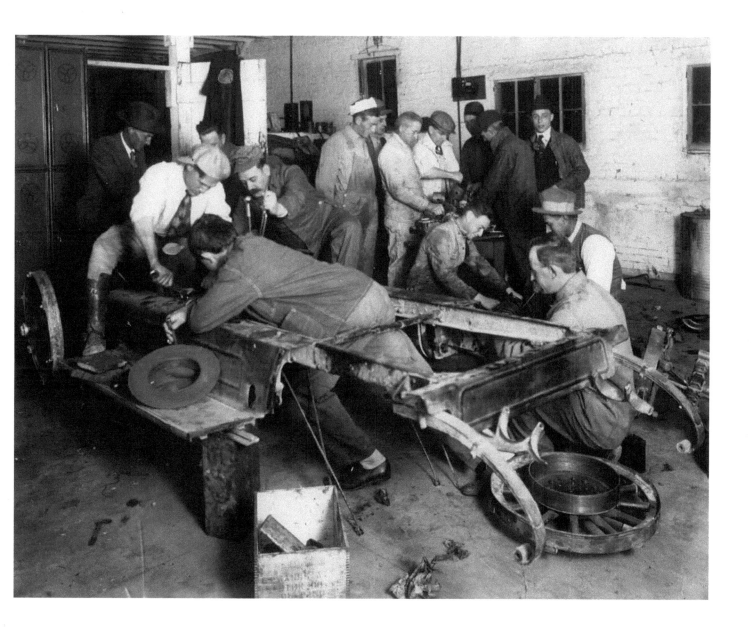

Automotive shop workers assemble an early car—the wheels have wooden spokes.

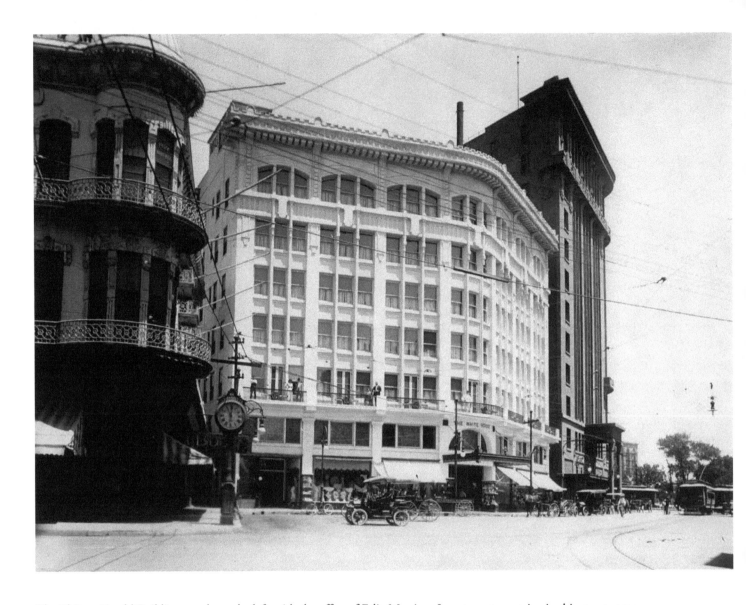

The El Paso Herald Building stands on the left, with the office of Felix Martinez Investments upstairs, in this street scene from about 1912. Emblazoned above the clock is the name A. D. Foster Co., a jewelry firm in the Herald Building. Henry C. Trost was the architect of the terra-cotta building in the middle, at 109 Pioneer Plaza, which has the White House Department Store downstairs and the Hotel McCoy, owned by W. M. McCoy, upstairs. The tall building on the right, the Mills Building, was designed by Trost for Anson Mills in 1911.

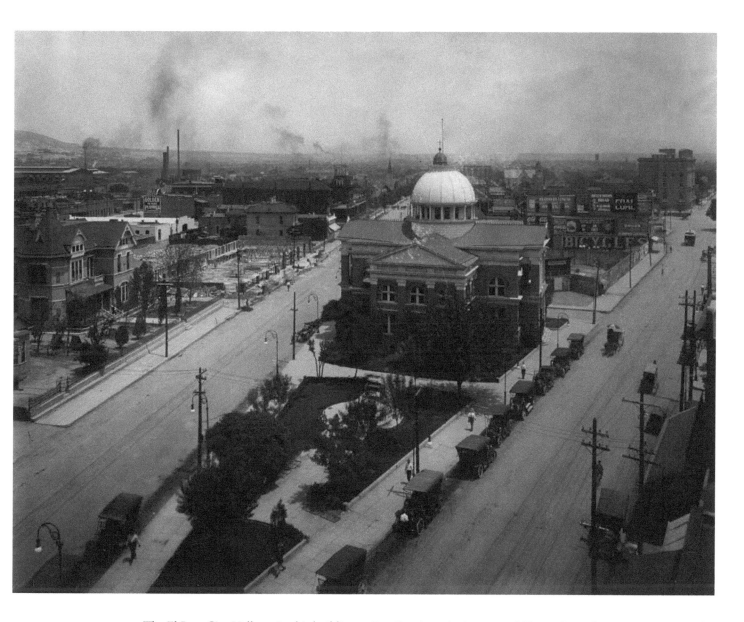

The El Paso City Hall was in this building at East San Antonio Avenue and Kansas Street from 1899 to 1959. The building cost $57,000 to erect. The signs behind it advertise bicycles and coal. In addition to city business, the City Hall was used for social occasions and functions.

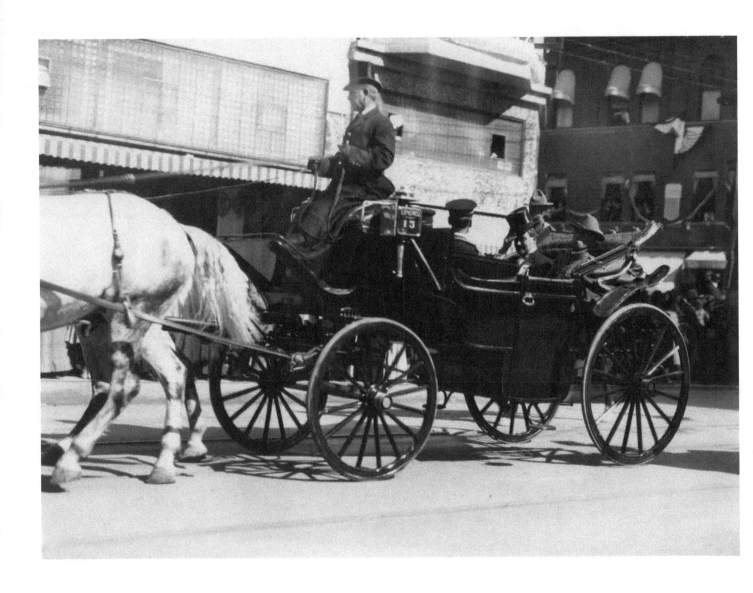

This picture was taken when President Theodore Roosevelt came to El Paso, in March of 1911. Colonel Edgar Z. Steever, Commander at Fort Bliss, is in the carriage.

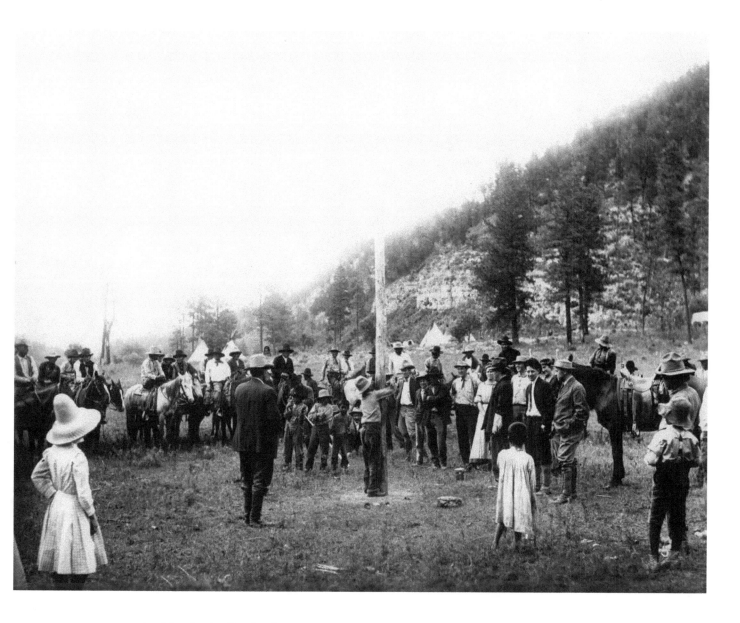

A celebration in Cloudcroft, New Mexico, in 1911. The Alamogordo and Sacramento Railroad would take people from El Paso up into the mountains for a summer getaway. El Paso residents still go to Cloudcroft in the summer to cool off and enjoy the clean mountain air.

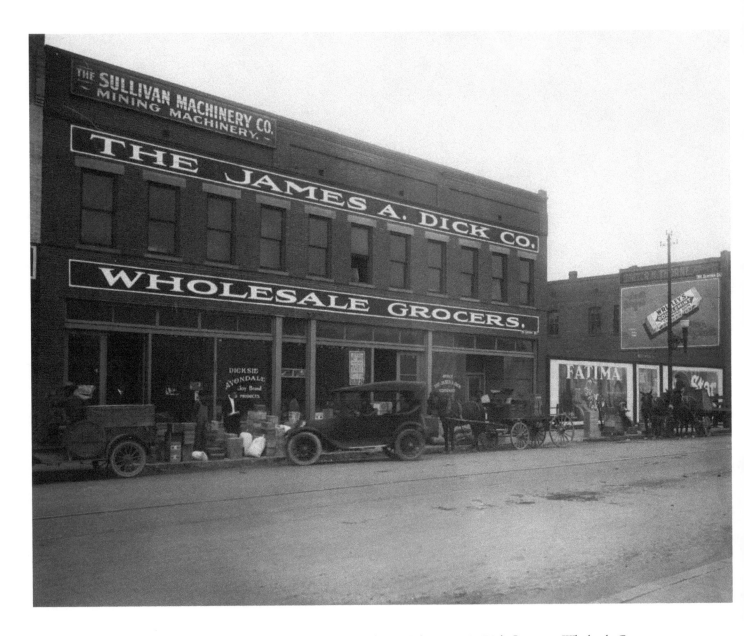

On Mills Street, the Sullivan Machinery Company sold mining machinery. The James A. Dick Company Wholesale Grocers offered a wide variety of products.

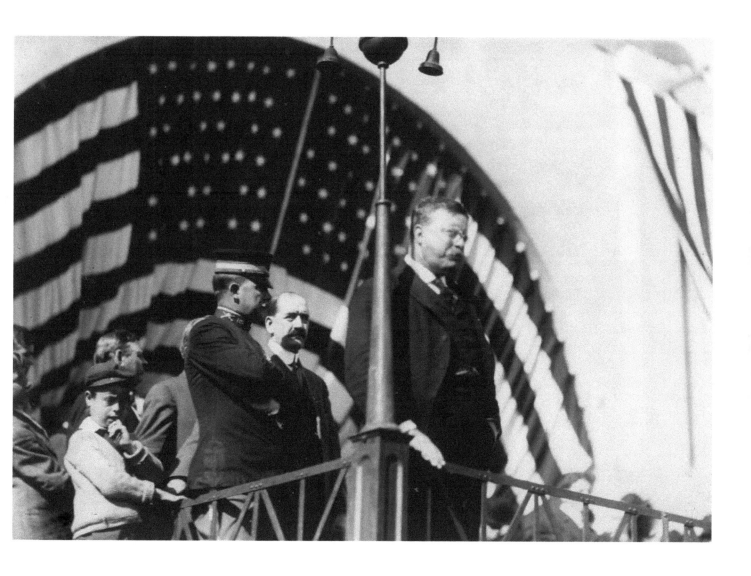

President Theodore Roosevelt stopped in El Paso while on his way to Arizona for the dedication of the Roosevelt Dam, in March 1911. A United States Army officer is standing behind him.

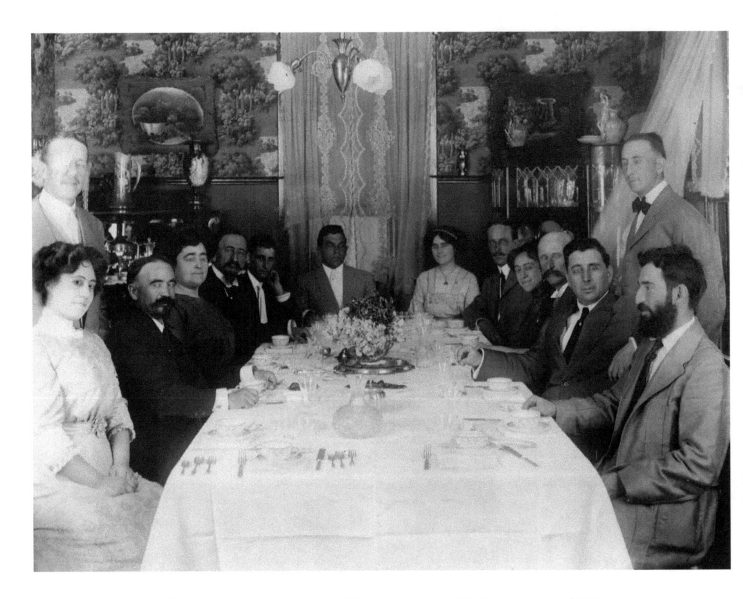

The Francisco Madero family, being entertained at the home of Mr. and Mrs. Frank Wells Brown, in May of 1911.
Madero, one of the leaders of the Mexican Revolution, wanted democracy in Mexico. The rebel armies were in Juárez,
trying to set up a provisional government, and Madero used the Sheldon Hotel in El Paso as his headquarters. Many in
El Paso supported Madero, and the arms his forces used were bought in town and taken across the Rio Grande.

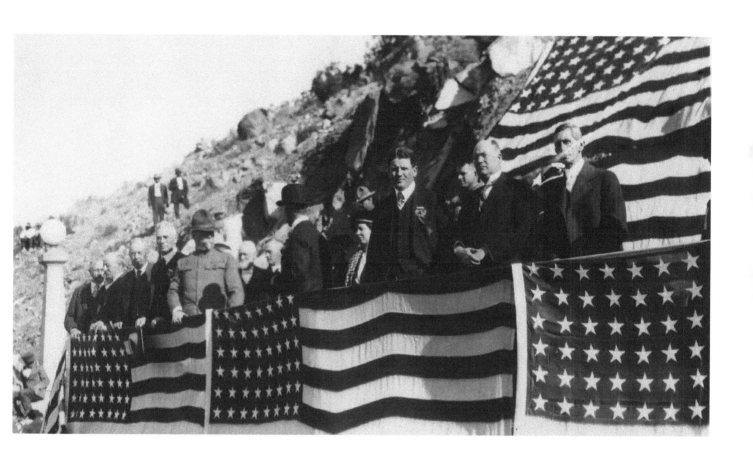

Over 300 people from El Paso were on hand this day in 1916 for the dedication ceremony for the Elephant Butte Dam, which gave a steady, reliable water supply to El Paso and helped control flooding.

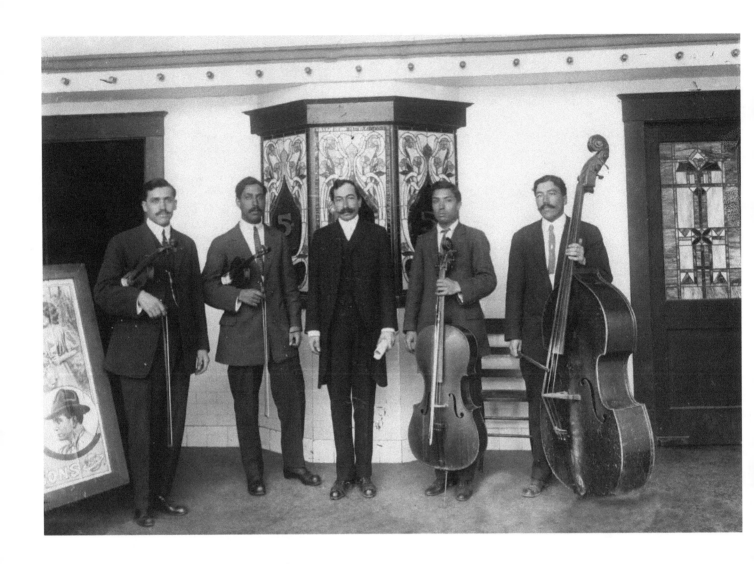

It cost a nickel to see the Universal silent film being shown at this theater. The musicians and conductor here would provide the music accompaniment. El Paso has a very rich musical tradition that is a blend of cultures.

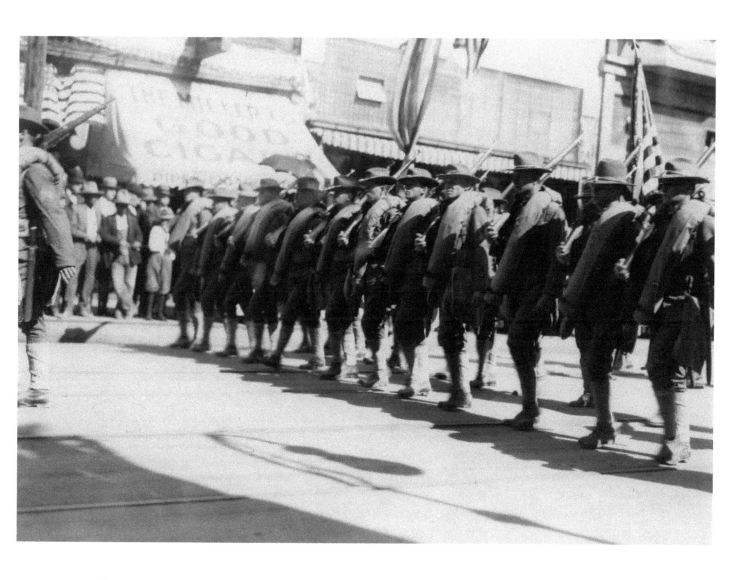

The 1911 Arizona–New Mexico Statehood Jubilee parade anticipated the admission of New Mexico, the forty-seventh state, to the union on January 6, 1912, and of Arizona, the forty-eighth state, on February 4, 1912. The awning of Miller Company Good Cigars can be seen behind the parade crowd.

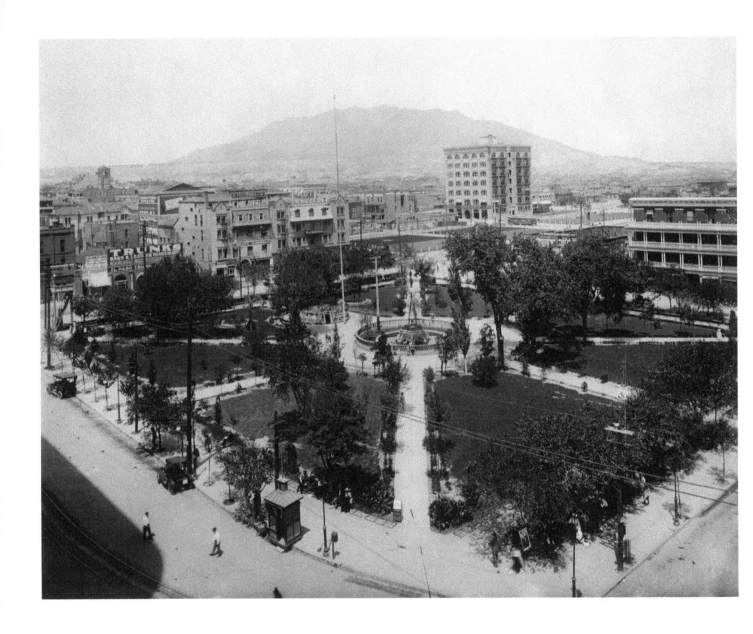

Looking toward the Franklin Mountains, this view is across San Jacinto Plaza, named in honor of the famous Texas battle of San Jacinto. Chinese elms were planted in the park, behind which, on the left, El Paso Trunk can be seen. Hotel Angelus and Hotel Delmar are in front of the mountain.

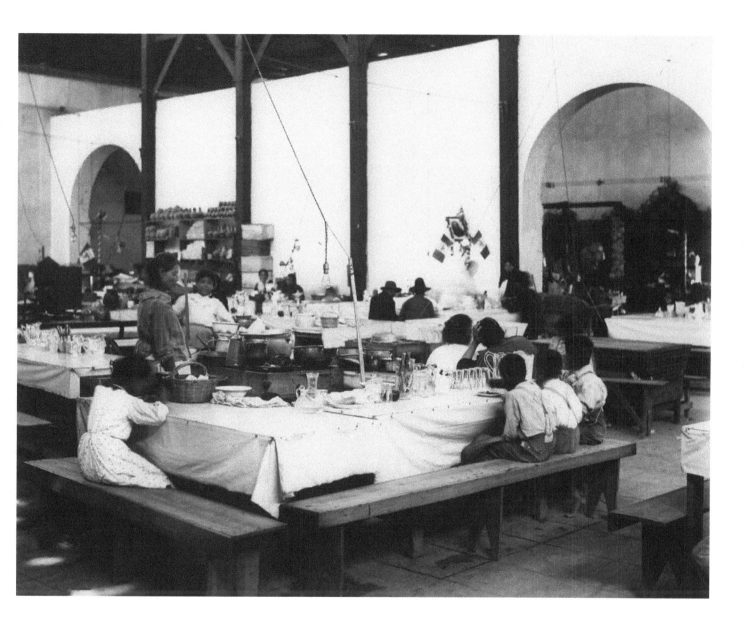

In this 1910 photo of a Juárez restaurant, the cooking takes place at a spot in the middle of the tables. Zona Pronaf Mercado, a Juárez public market, had stalls for small businesses. It was torn down in the 1990s, and Plaza de las Americas replaced it. El Mercado Juárez provides the old market experience and is run by the Juárez Municipal Government.

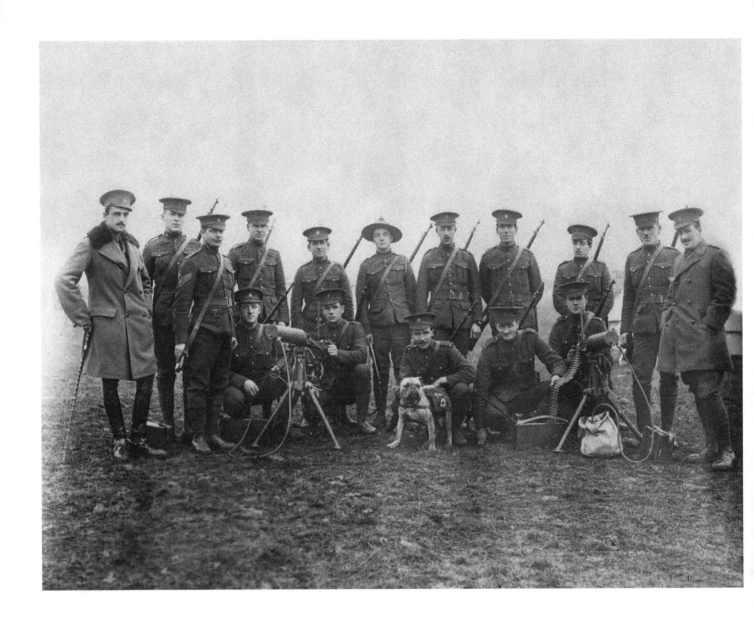

In this image from Fort Bliss, a group of English officers, a doughboy (center), and a medic pose with a pair of water-cooled machine guns and a bulldog carrying a first-aid pack.

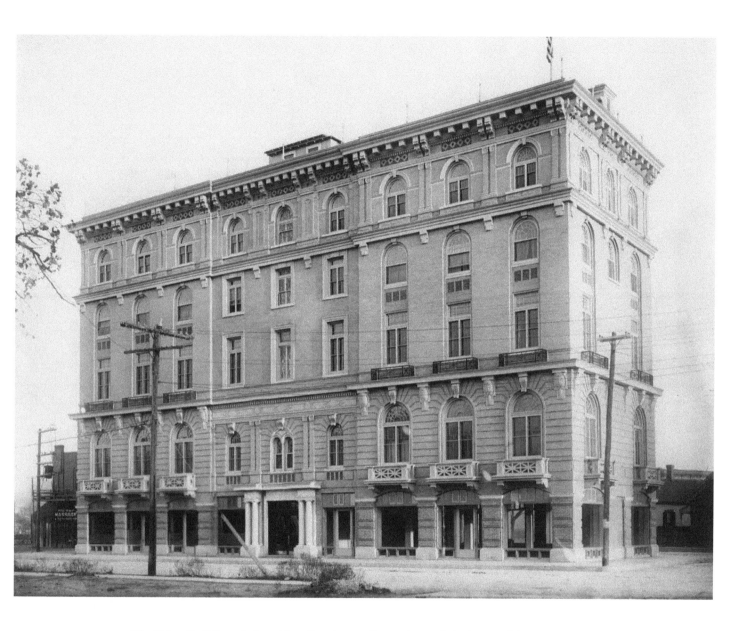

The Toltec Building, designed in a Renaissance Beaux-Arts style by Henry C. Trost, is at 602 Magoffin Avenue. Trost was a member of the Toltec Club, which was a men's club inside the building. The Toltec Club was the site of a victory banquet put on by city leaders for Francisco Madero in 1911, during the Mexican Revolution.

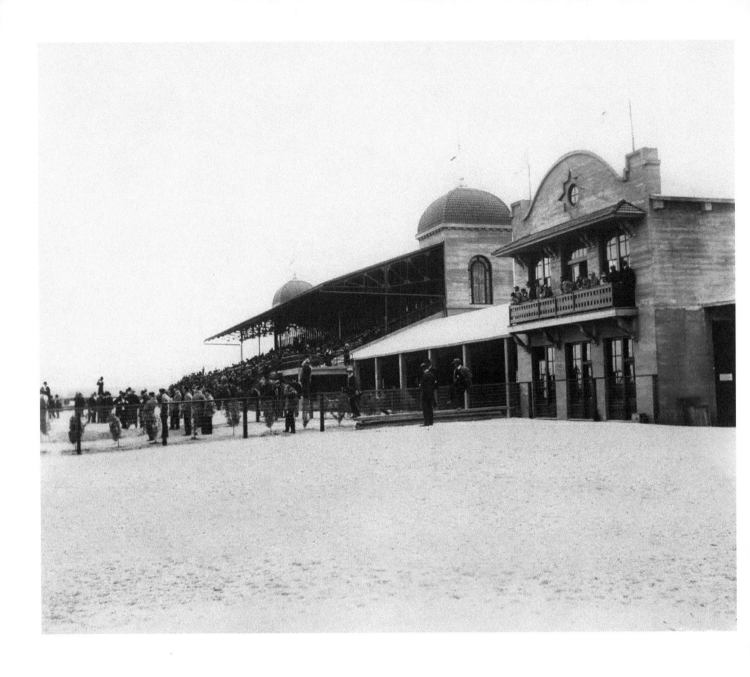

Juárez Racetrack always attracted a crowd, with horse races and dog racing featured. Otis Aultman was the official photographer for the track for several years. He took photos of many of the horses and the ends of all the races.

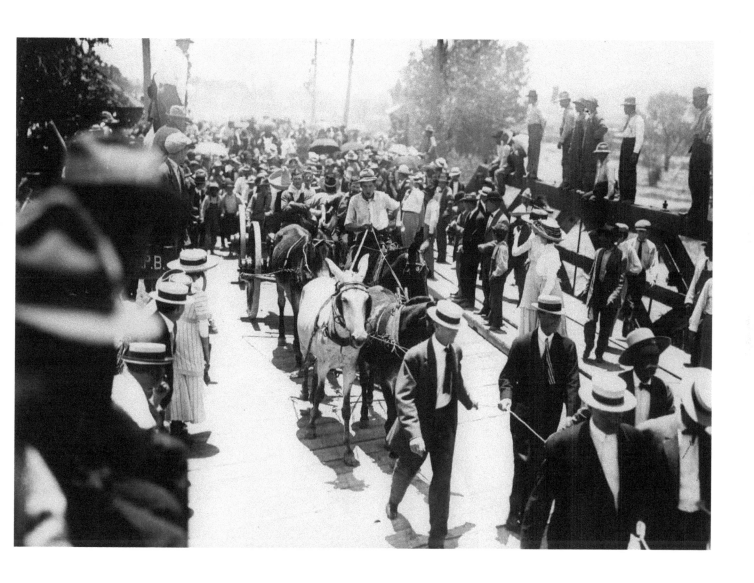

The McGinty Club's muzzle-loading cannon, called the Blue Whistler, was returned to El Paso over the bridge from Mexico in 1911. The Mexican revolutionary armies used the cannon against the Mexican federal troops.

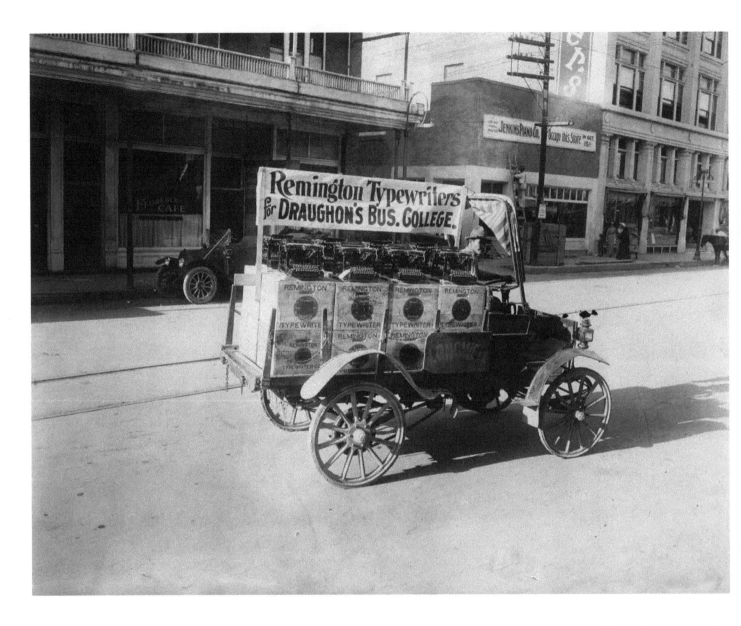

The Longwell Transfer Company, operated by J. J. Longwell at 116-18 San Francisco Street, owned this multipurpose truck. The Remington Typewriter Company was at 204 Texas Avenue, and in 1916 the Draughon's Business College was listed as in the Trust Building. Behind the pole one can just make out the Jenkins Piano Company.

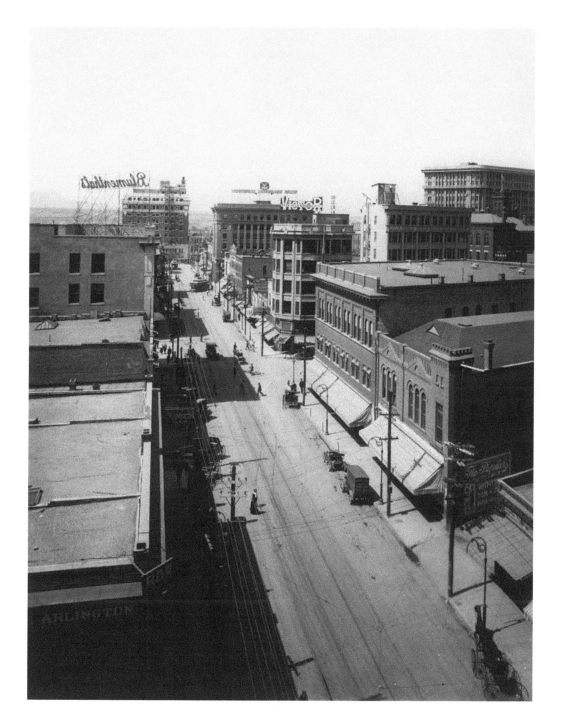

Blumenthals Clothing can be seen at the end of San Antonio Avenue, at 100 South El Paso Street, and in the upper right, the Mills Building, at 303 North Oregon Street. The Mills Building was owned by Anson Mills and was completed in 1911. Henry C. Trost designed the all-concrete structure, and the firm of Trost and Trost had its offices there.

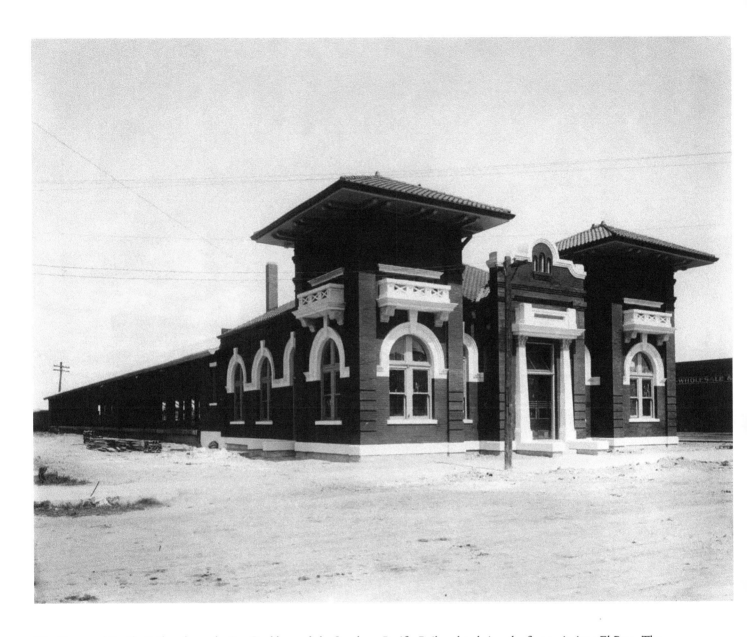

The Texas and Pacific Railroad, run by Jay Gould, raced the Southern Pacific Railroad to bring the first train into El Paso. The Southern Pacific won the race. The Texas and Pacific Railroad Freight Station, seen here in 1912, is now the GLBT Community Center, at 216 South Ochoa Street.

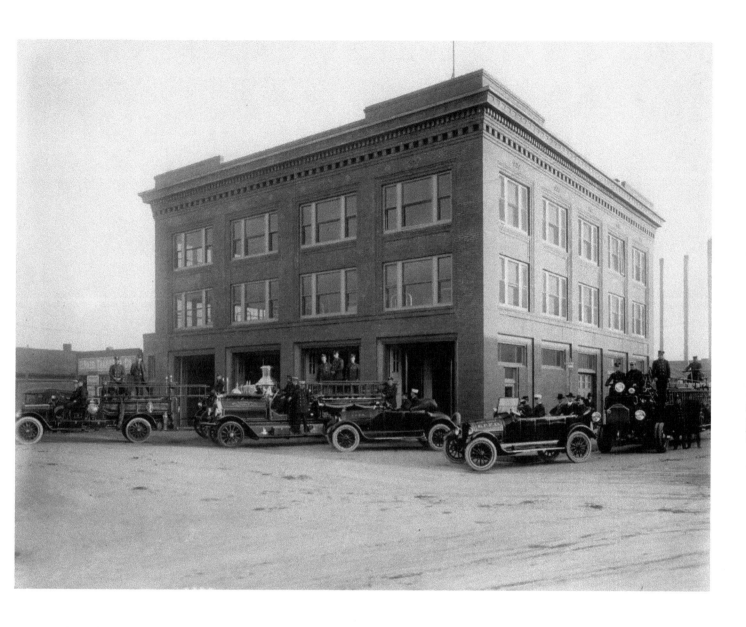

Central Fire Station, 600 East Overland Avenue, in 1915. The El Paso Hose Company No. 1 started out on August 22, 1882, as a volunteer fire department. The company contracted with Sylvester Watts to build a waterworks for the city residents and to provide 25 fire hydrants. When a fire broke out the same year, two buildings were lost because the fire hydrant was across the street, and they only had 100 feet of hose. In 1909, the city went to a paid fire department crew, with W. W. Armstrong as the first fire chief.

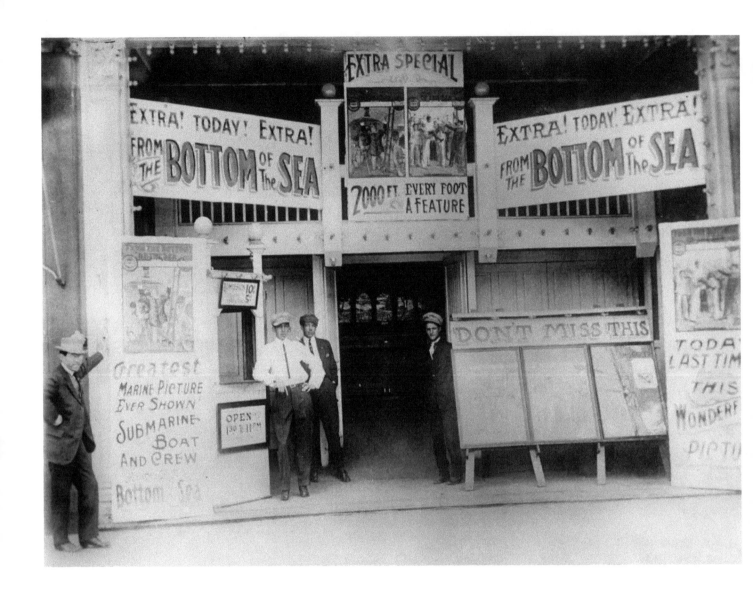

This day was the "last time" one could see the 1911 silent movie *From the Bottom of the Sea* at the Alhambra Theater. Starring Mary Pickford and Charles Arling, it was promoted as the "greatest marine picture ever shown."

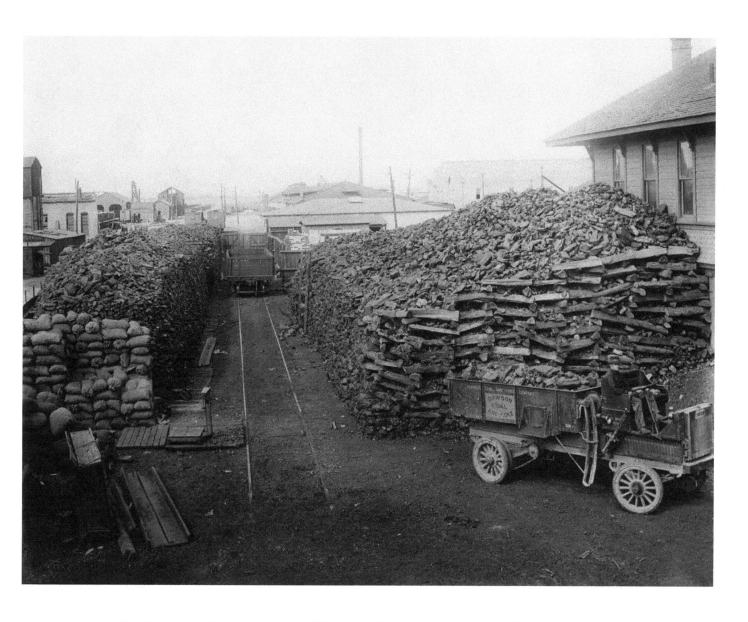

Coal heating supplies were brought to El Paso by railroad, and the Dawson Fuel Sales Company would load them onto the company truck for delivery to customers, as in this 1913 photo. The Dawson firm was managed by G. M. Hanson at 710 Mills Building. By 1916 there were seven additional wholesale coal suppliers in El Paso.

This Spanish colonial, Moorish-style building, designed by Henry C. Trost, opened in 1914. The Alhambra Theater, at 209 South El Paso Street, had a large organ to provide music for silent movies and live theater. Alhambra Jewelry was at 211 South El Paso, and the Singer Sewing Machine Company was on the right, at 205. The Alhambra became the Palace Theater and is on the National Register of Historic Places.

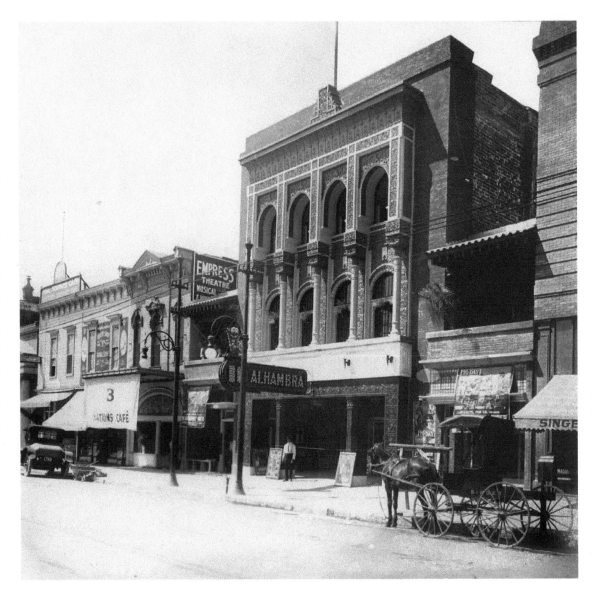

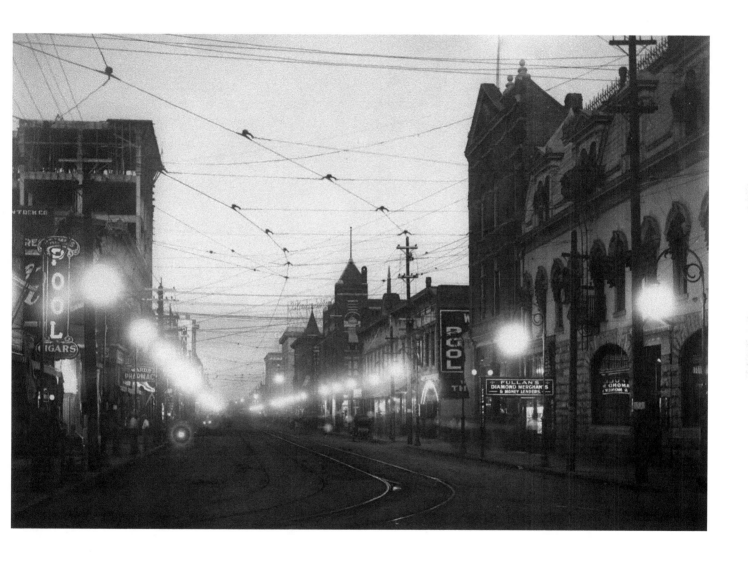

Streetlights blaze on San Antonio Avenue, with Michelson's Pool and Cigars on the left, and behind it a new building under construction. Across the street is Blumenthal's Clothing, at 300 San Antonio, and on the right is A. J. Fullan Pawnbroker, Diamond Merchant, and Money Lenders, at 102.

In the distance beyond Foutz and Moore Furniture Company, owned by Charles Foutz at 113 North Stanton Street, a towering sign urges locals to "use electric light." In the 1880s, Mayor Joseph Magoffin and the city council organized Brush Electric Company; in 1890 Zach White took it over. Mr. White had electrical generating equipment installed at a plant at Chihuahua Street and Third. In 1889, the state issued a charter to the International Light and Power Company to provide power for El Paso and Juárez.

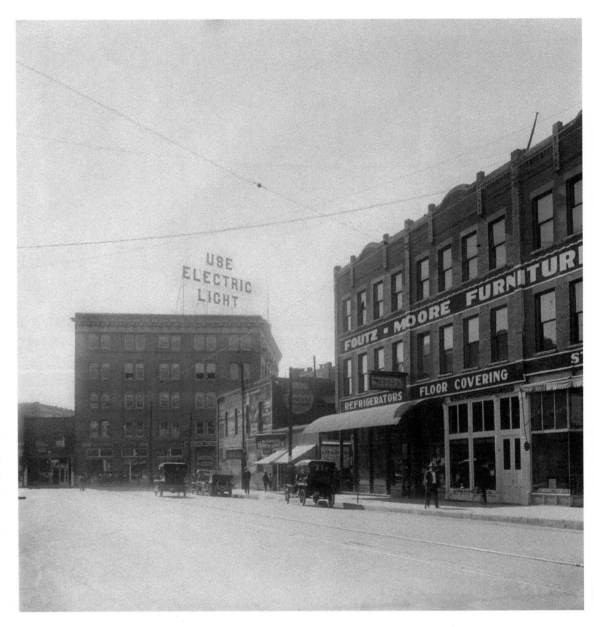

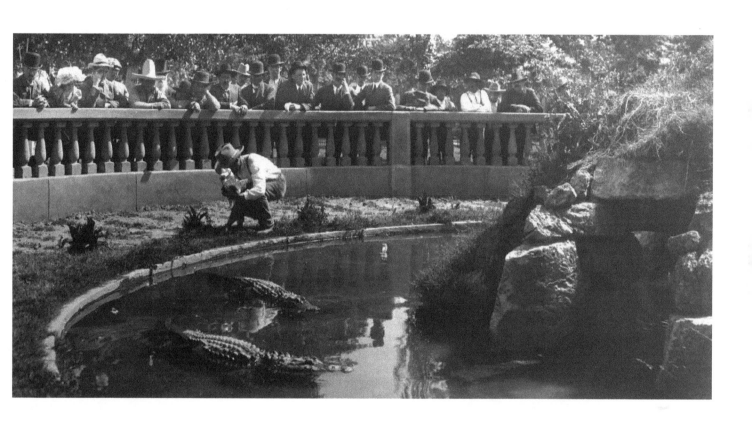

Live alligators were kept in the fountain pool at San Jacinto Plaza beginning around 1890. The artist Luis Jimenez grew up in El Paso, and his father, a neon sign artist, often took young Luis to see the alligators. As an adult, Luis Jimenez was commissioned to create a sculpture of airbrushed fiberglass, in vibrant colors, for the park. The sculpture, Plaza de los Lagartos, can be enjoyed by all who visit there.

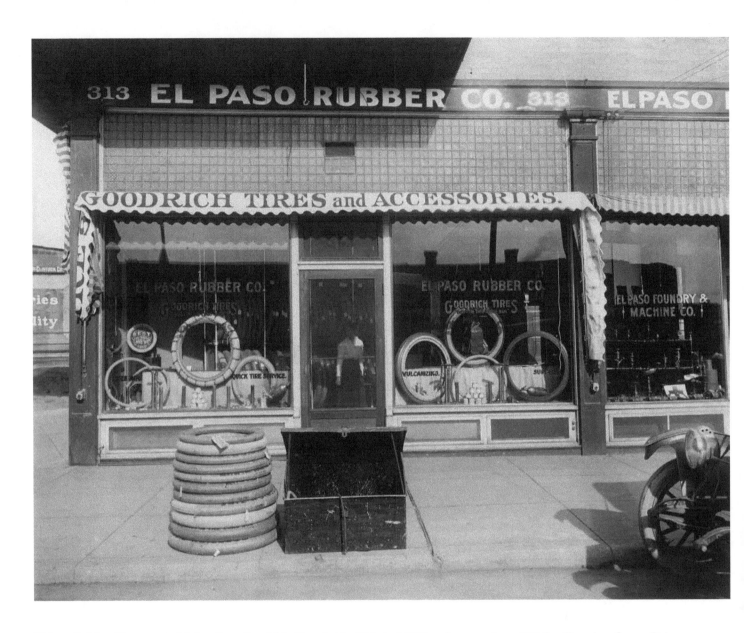

El Paso Rubber Company sold tires from Goodrich (founded in Ohio in 1870) and accessories at 313 San Francisco Street. Drivers would carry their own pumps and patch-kits to fix flats on the road. El Paso Foundry and Machine Company, at 311 San Francisco, was established in 1888 to manufacture iron castings.

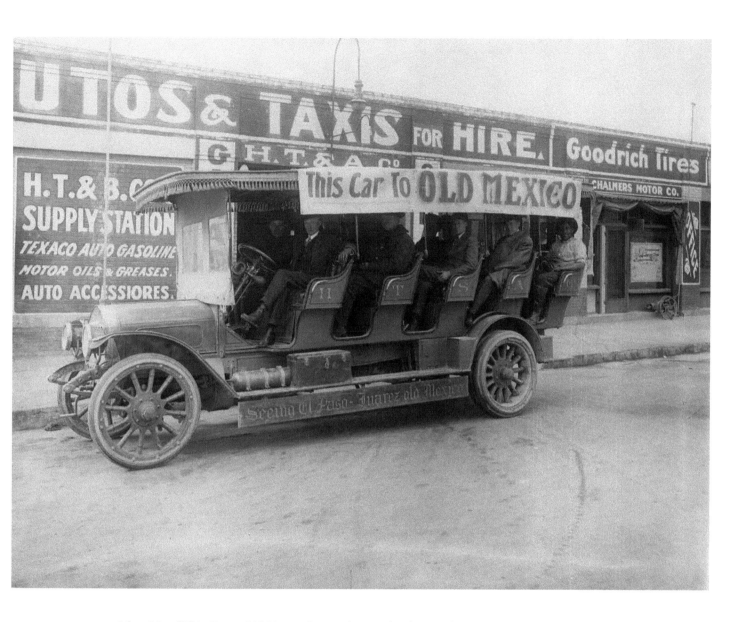

Advertising "This Car to Old Mexico," a tour bus run by the Hotel, Taxicab, and Baggage Company took people to see the sites of El Paso and Juárez. One could ride the bus, see some local scenery, and learn some history, much as one can still do by tour bus today.

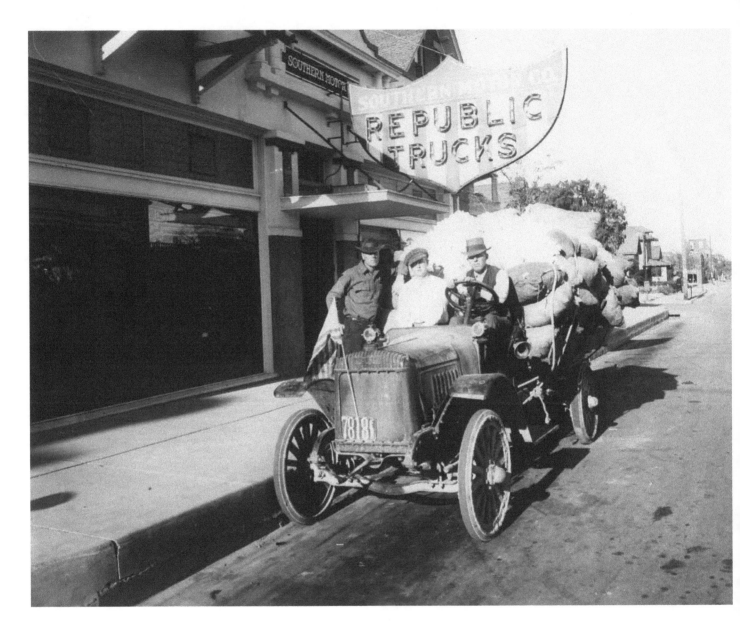

This loaded-down vehicle is parked in front of the Southern Motor Company, which according to the 1916 El Paso city directory was at 355 Myrtle Avenue, with M. J. Roseboro as the manager. Republic Trucks were built until about 1929.

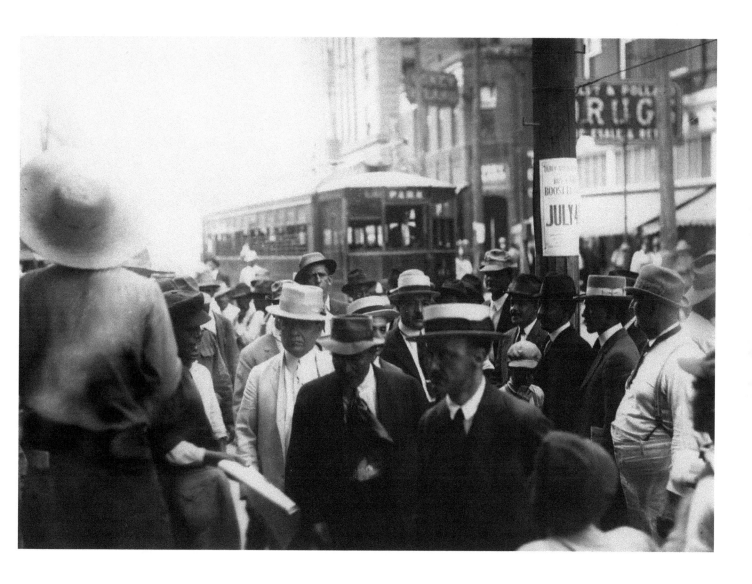

The arrest and imprisonment of General Huerta attracted large crowds and kept El Paso busy. The whole continent was intrigued and awaited news from the city. El Paso had been the center of national attention since the Mexican Revolution started in 1910 and was overflowing with activity, much of it covert. Many people from Mexico moved to El Paso to get away from the war.

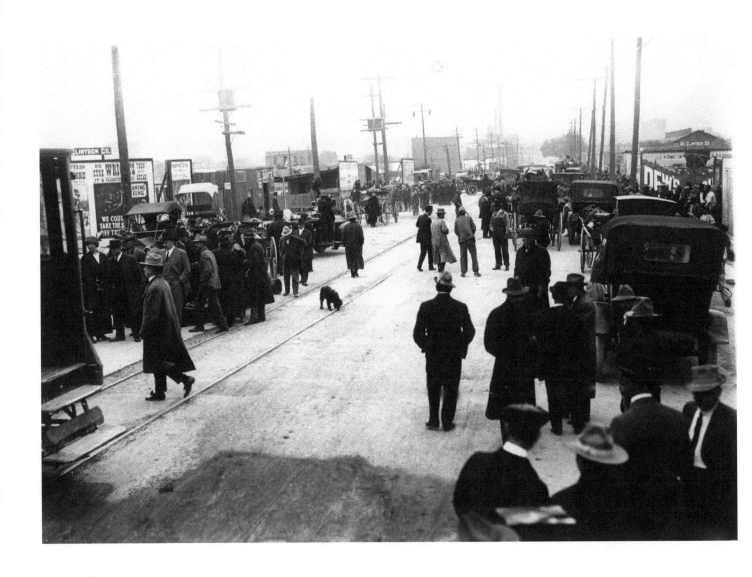

During the Battle of Ciudad Juárez, in 1911, the people of El Paso watched the fighting go on for three days, some of them viewing from boxcars and rooftops. Photographer Otis Aultman was often in the middle of the Mexican Revolution battles with his camera.

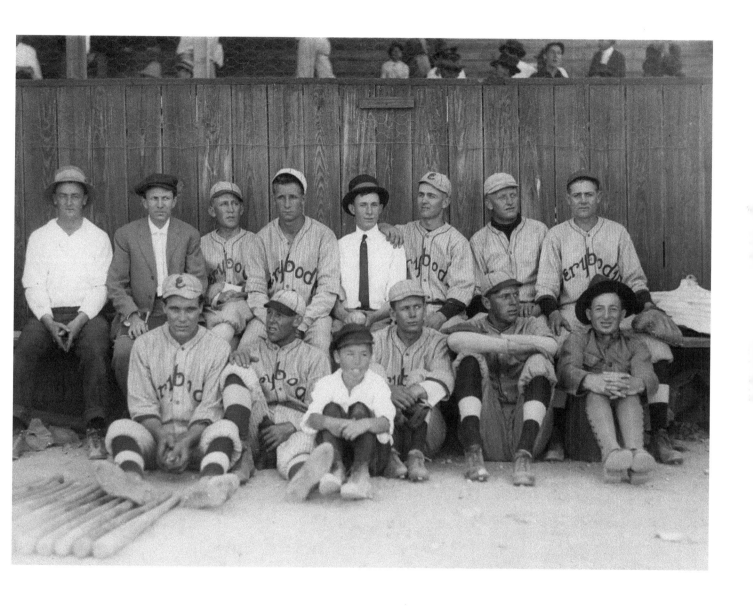

Baseball has always been popular in El Paso, as can be seen in this photo of Everybody's Baseball Team, which had a soldier on the squad. Everybody's Department Store, managed by I. M. Mayer at Stanton and Texas Avenue, sponsored the team.

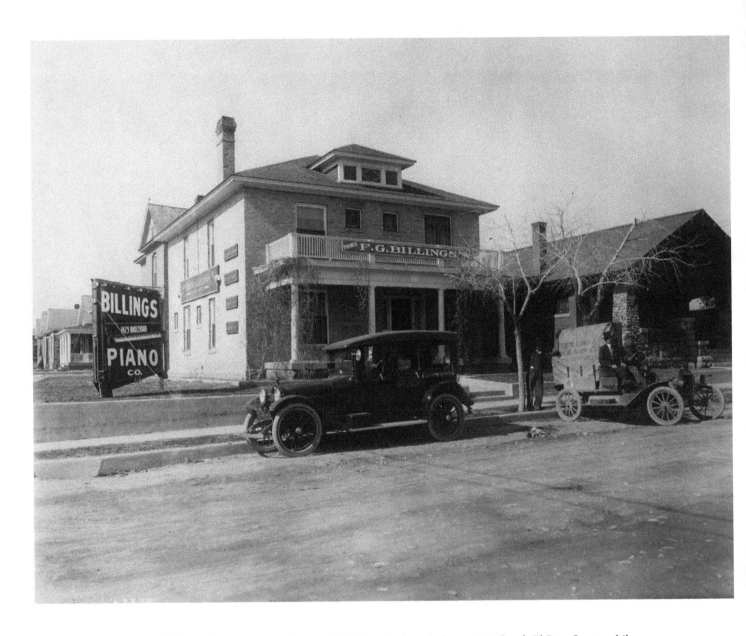

City directories list F. G. Billings Company Music Store at 1429 East Boulevard, then at 103 South El Paso Street, while signage on the delivery truck suggests a third address on North Stanton Street. In addition to pianos and other musical instruments, Billings sold Victrolas.

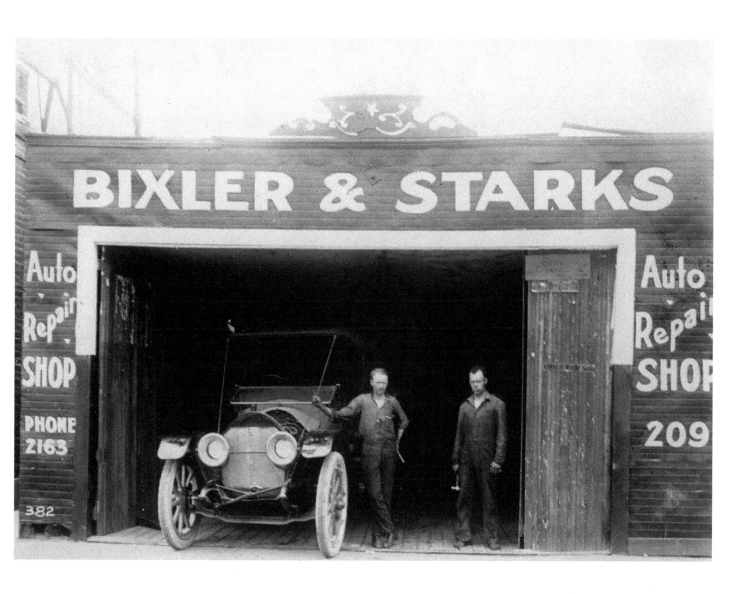

Businesses such as Bixler & Starks Auto Repair Shop heralded the increasing impact of the automobile on life in El Paso, as elsewhere.

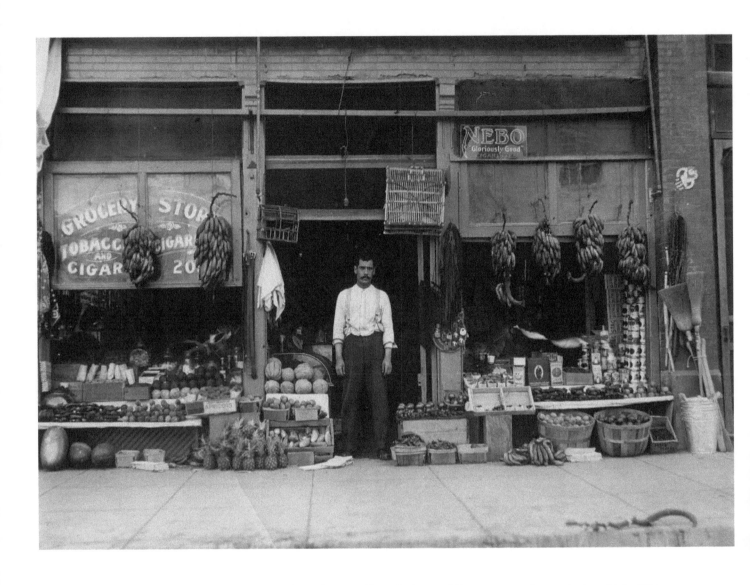

The grocery store proprietor at 402 San Francisco Street kept a well-stocked store. His customers who smoked could find Prince Albert and Stag tobacco, cigars, and Nebo cigarettes advertised as "gloriously good." He also sold Imperial Oats, pineapples, apricots, melons, bananas, and even locks and brooms.

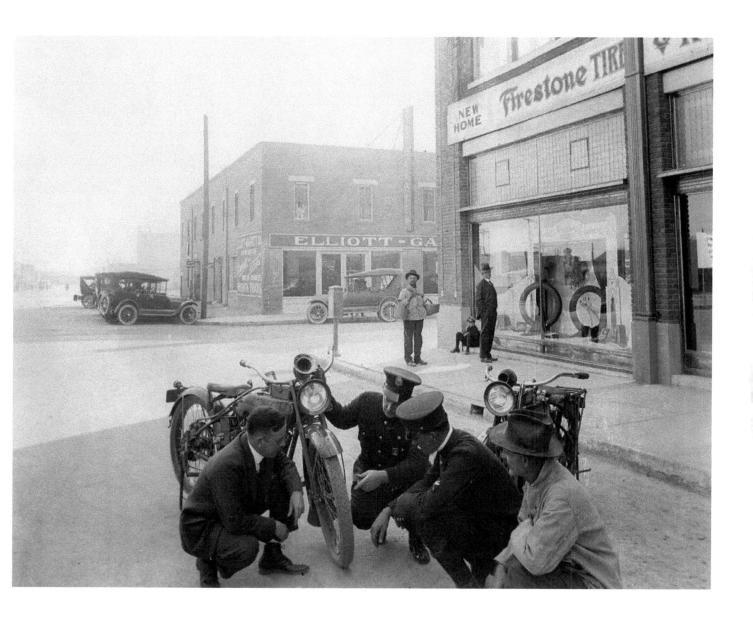

The El Paso Police Department was established in 1884. Here, in front of Liberty Hall, on Overland Avenue, two motorcycle officers examine one of the tires on their Harley-Davidsons, perhaps with a mind to replace it with a new Firestone. Christmas greetings can be seen in the windows. Across the street is the Elliott-Garrett Auto Company. F. J. Garrett was the manager.

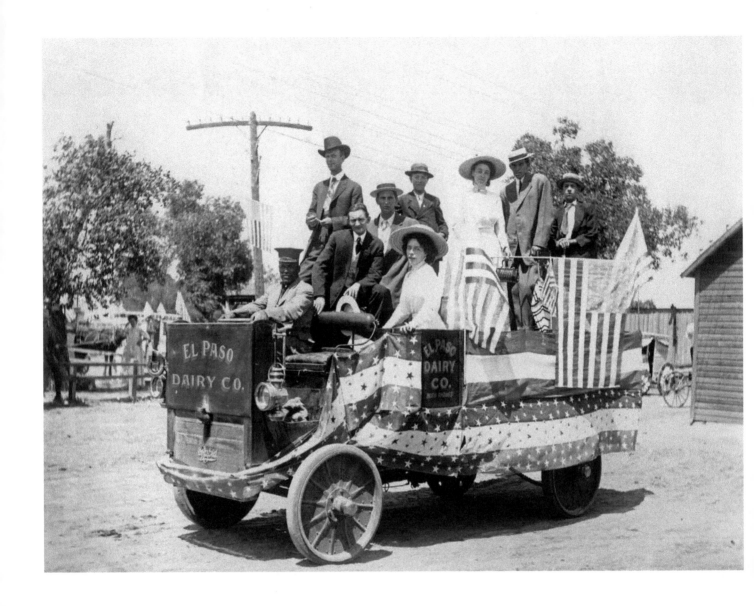

The owner of this parade-ready company truck, El Paso Dairy Company operated at a succession of addresses. These included 423 North Oregon Street, in 1916, with A. G. Foster as general manager, and 423 Mesa Avenue, in 1922, with J. A. Smith as manager and secretary. Price Dairy bought the firm in 1927, and a little later it became Price's Creameries.

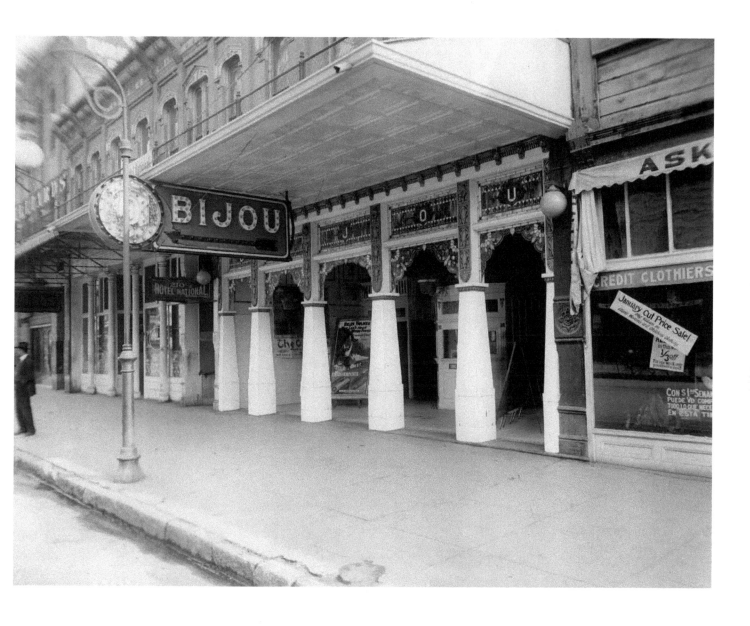

The Bijou Theatre, at 202 South El Paso Street, is showing *The Leap from the Water Tower*, an episode of a serial with Helen Holmes, produced by J. D. McGowan. The Bijou has nice stained-glass windows. Built in 1906, it started out as the Standard Theatre. A clothier on the right is having a January sale. On the left is the Hotel National, at 210 1/2 South El Paso Street, run by M. S. Medlock.

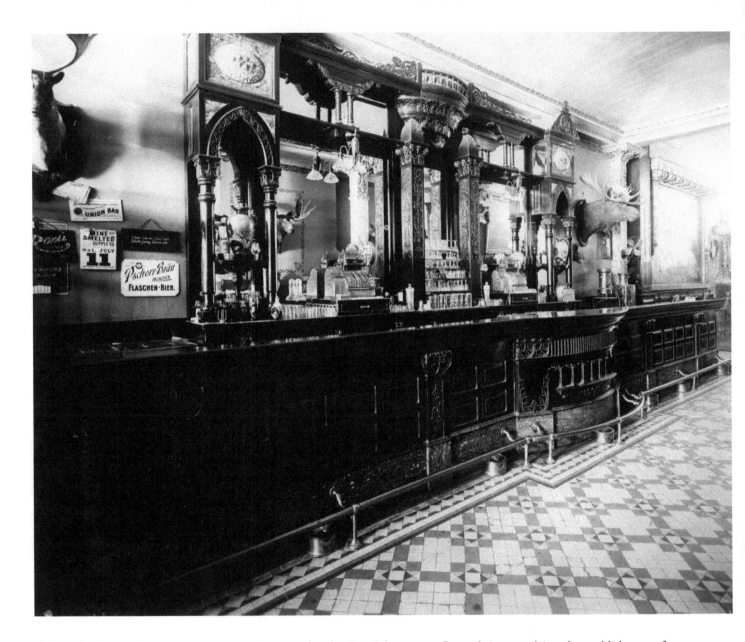

Behind the bar and between the moose heads mounted at the Gem Saloon, one of several signs proclaims the establishment of a union bar, and another advertises Pschorr-Brau Munchen Flaschen Bier. In 1888, the Gem Saloon and Gambling was at 127 South El Paso Street, with J. J. Taylor and George Look in charge. In the early days, the Gem had a vaudeville theater too. Gambling became illegal in El Paso in 1905.

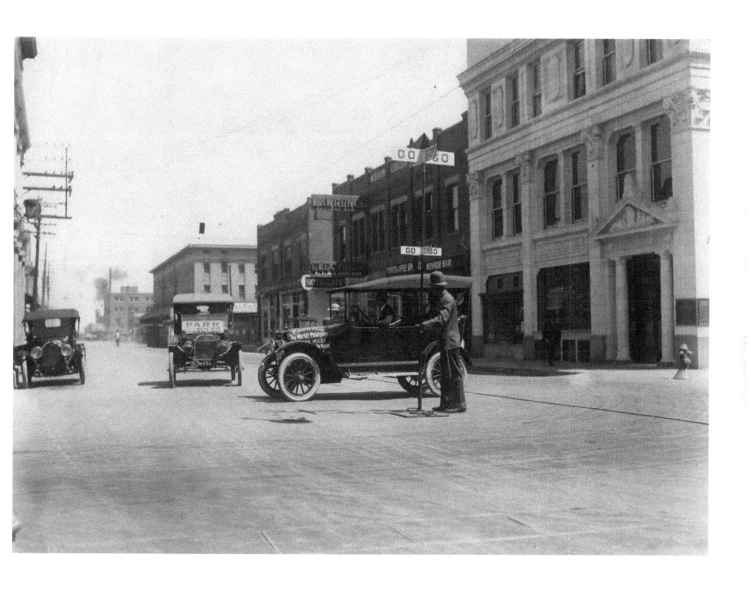

Traffic at the intersection of Mills and Mesa is controlled by an El Paso police officer using a hand-operated traffic signal. Looking east on Mills Street, this view includes the Commercial National Bank on the corner; C. B. Hudspeth was bank president. Farther down the block at 206 Mills Street is the Success Café, whose proprietor was Mrs. R. C. Woods.

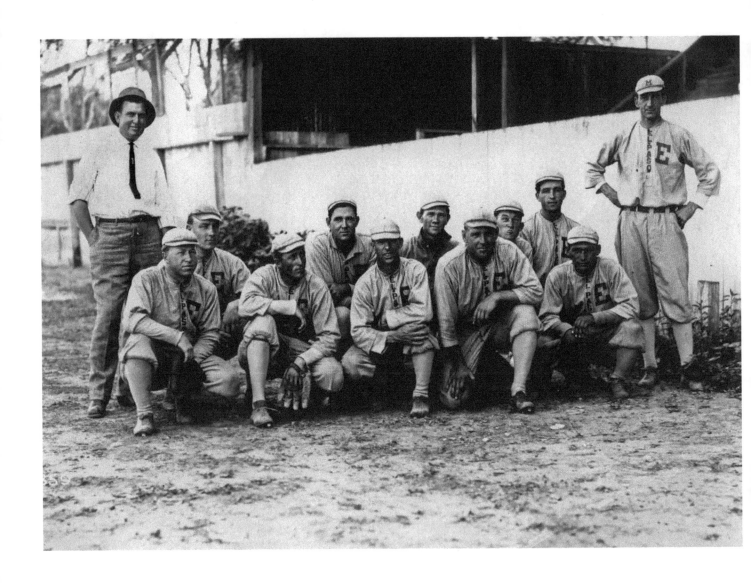

A group portrait of the El Paso baseball team. In 1884, El Paso organized a baseball team, called the El Paso Blues because they wore blue uniforms. By 1886, the El Paso Browns, with brown uniforms, were the pride of the city, and merchants closed their stores on Saturday so everyone could go to their games. The McGinty Club Band played music at the games, and fellow member Charles J. Jones managed the team.

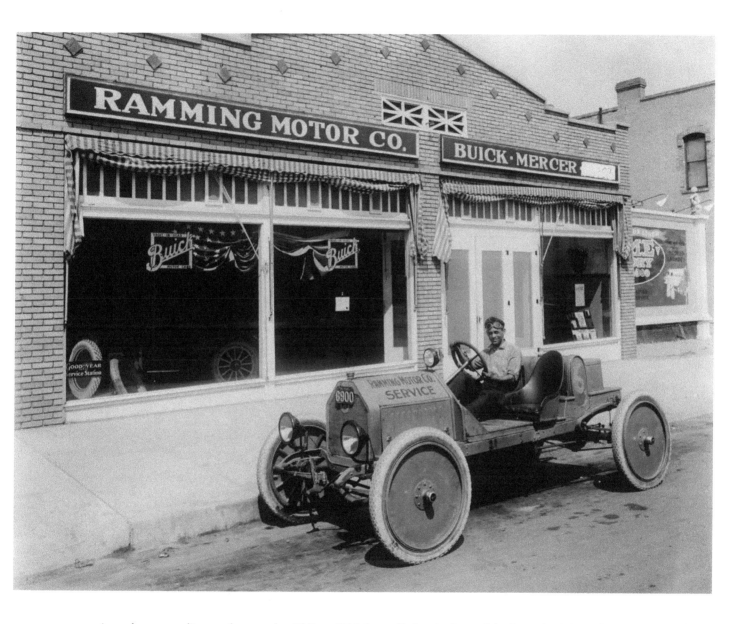

An early race car, license plate number El Paso 6900, has pulled up in front of the Ramming Motor Company, a Buick and Mercer dealer. On the right is the Acme Modern Laundry Company, at 901 East Missouri Street.

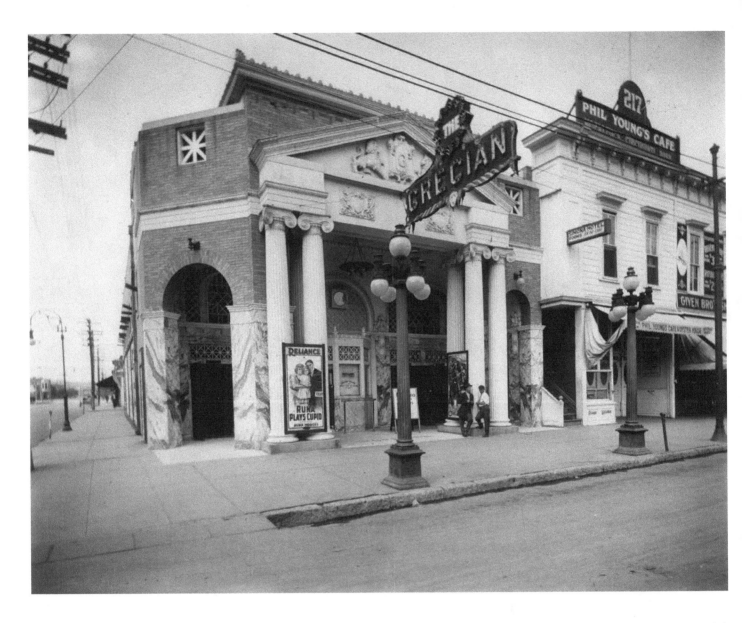

Runa Plays Cupid, starring Runa Hodges, was playing at the Grecian Theater at 219 South El Paso Street. After a movie, Phil Young's Café and Oyster House was a nice place to have dinner and a drink. Upstairs was the Simona Hotel. Given Brothers Shoe Company, at 215 South El Paso Street, is on the right side of the picture.

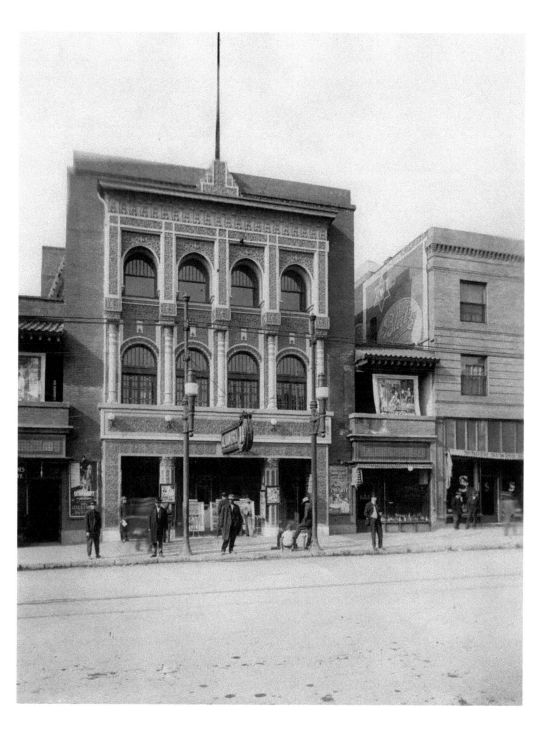

Featuring *Dancer and the King* on this date, the Alhambra Theater at 209 South El Paso Street had a plaster facade with an ornate design. The building originally included the two smaller ones on either side of it. The Rowen & Walker Saloon and the Singer Sewing Store can be seen on the right. A man is getting his boots shined in front of the theater.

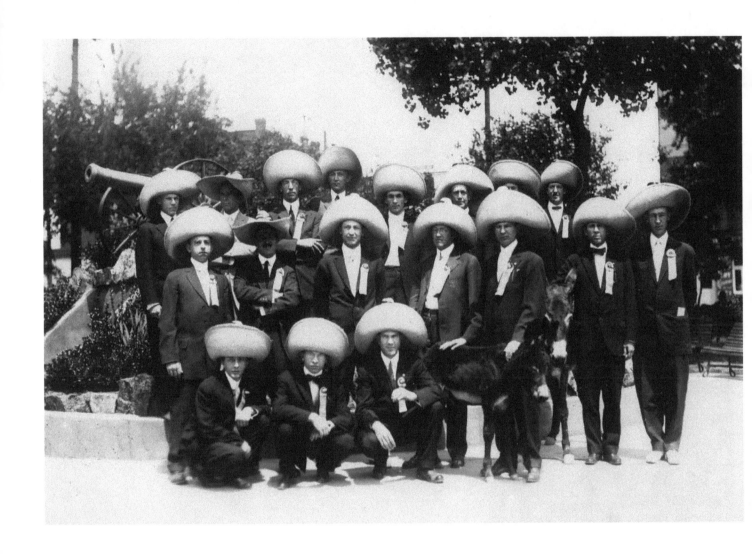

Posing in 1914 with two young donkeys, the Adventurers Club, formed by Otis Aultman, would meet, go on adventures, or just socialize whenever they were in El Paso. At various times, members of the informal club included Tracy Richardson, a soldier of fortune in the Mexican Revolution, and General John Pershing.

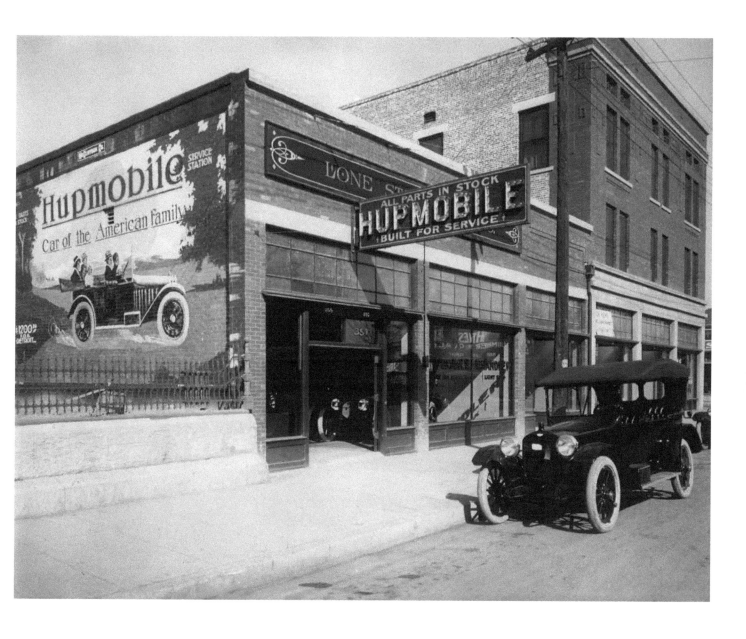

The Lone Star Motor Company sold Hupmobiles from the Hupp Motor Company. The make was built in Detroit from 1909 to 1940. Lone Star was listed at 355 Myrtle Avenue in 1915, and at 1500 Texas Avenue in 1936.

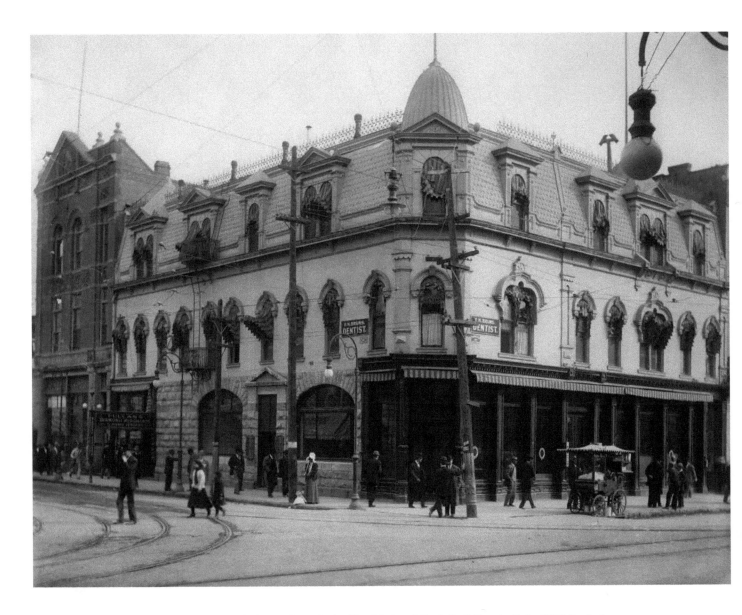

On the corner of San Antonio Avenue and El Paso Street is the First National Bank Building, built in 1883 for Joshua Raynolds, at 109 East San Antonio Avenue. John Wesley Hardin, a notorious gunfighter killed in 1895, is said to have had his law office on the second floor. First National Bank and American National Bank merged in 1914, and in 1915, F. H. Bruns Dentist Office and Pullans Diamond Merchants & Money Lenders operated from the building.

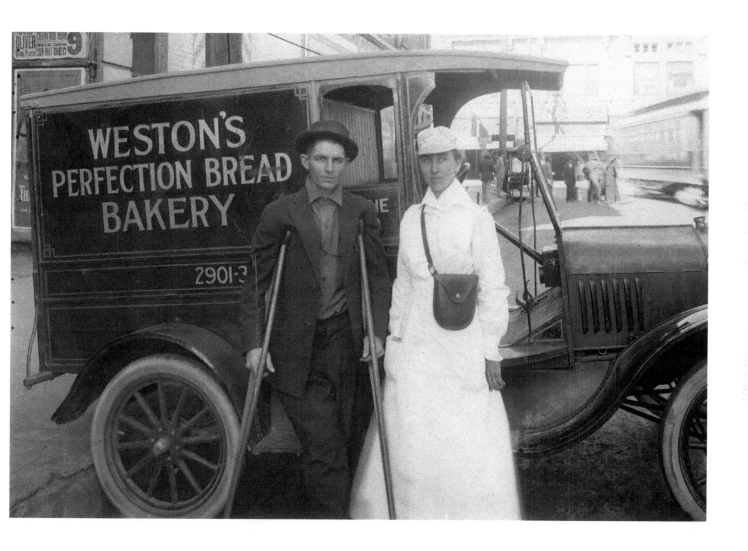

Weston's Perfection Bread Bakery Truck and staff, in 1918. The G. W. Weston Restaurant was at 320 San Antonio Avenue. The hat on the woman says Globe Mills Flour, which was from the El Paso Grain and Milling Company. A little to her right, the William Rosing Clothing Company can be seen, at 320 San Antonio Avenue.

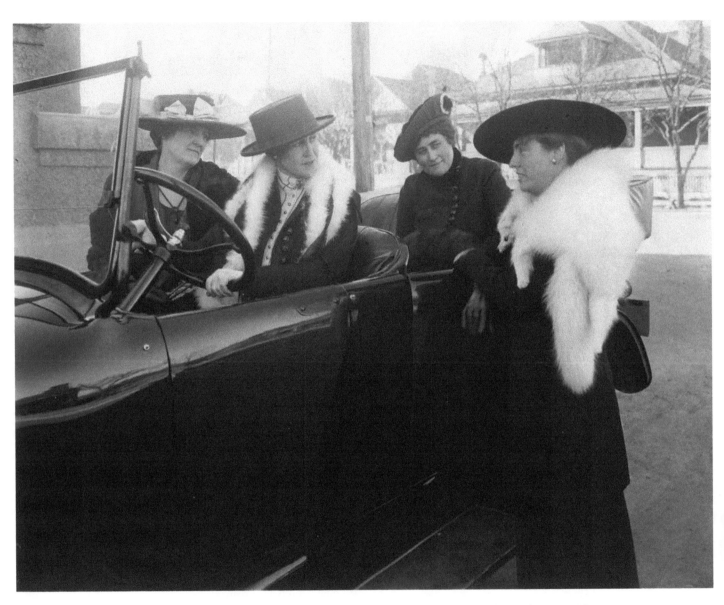

This gathering is at the Cooley residence at Rio Grande and Florence Street. One of the four ladies is Florence Milby.

The University Club, on the top floor of the Martin Building, April 1918. The seven-story Martin Building, at 215 North Stanton Street, was purchased by El Paso Electric Company in 1950.

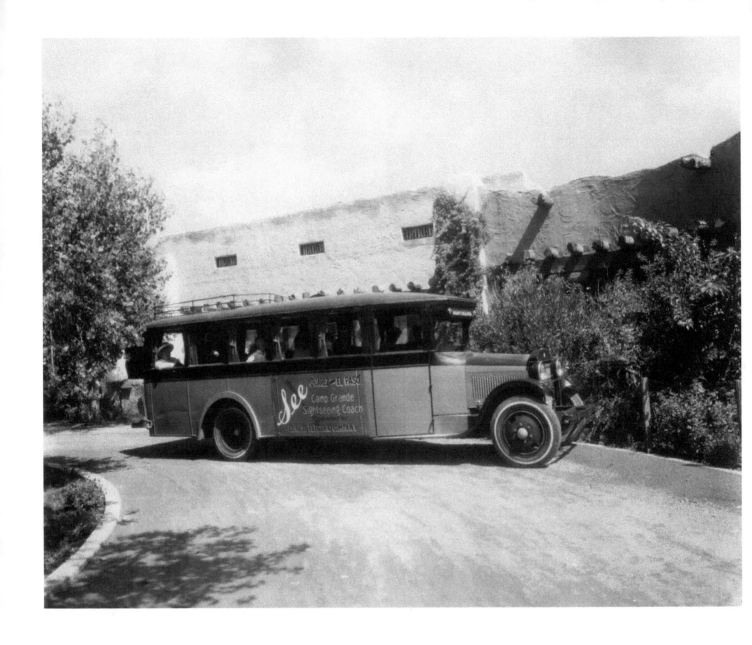

Operated by El Paso Electric Company, the Camp Grande Sightseeing Coach allowed one to see Juárez. During the Mexican Revolution, in 1911, Francisco Madero attacked the town of Casas Grandes, but the Mexican federal troops defeated his revolutionary army there. Later, General Orozco and General Villa captured Juárez.

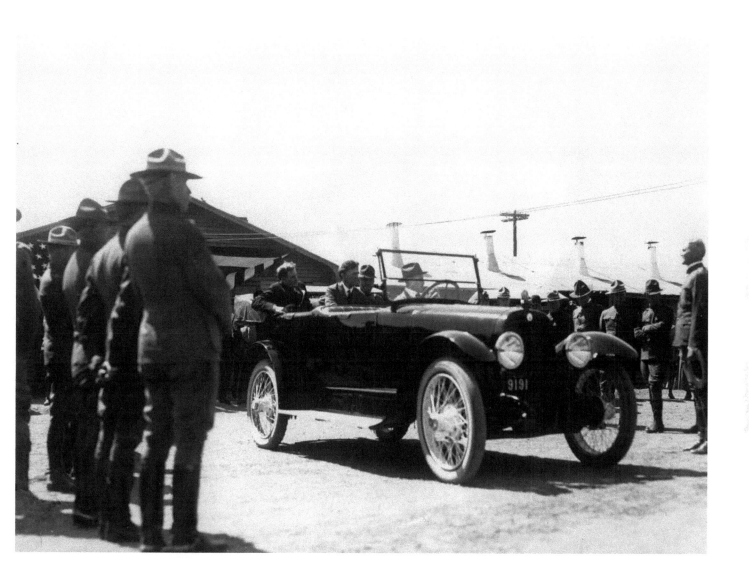

United States Cavalry officers from Fort Bliss are on review as a car, license plate El Paso 9191, goes by with dignitaries. On a separate occasion, a ceremony was given for General Pershing and his troops when they returned from the Punitive Expedition. The parade to honor the returning National Guard and Army troops was held in El Paso on February 6, 1917.

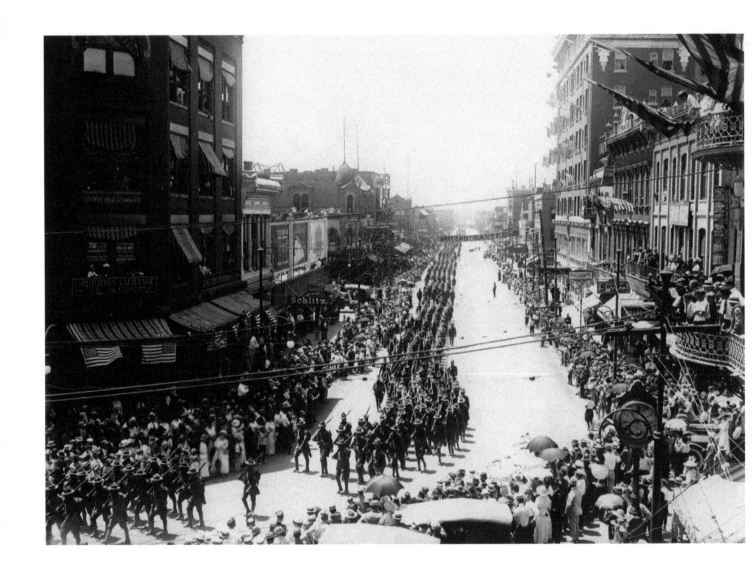

The United States Army Infantry marches north on South El Paso Street, passing through Pioneer Plaza. The banner draped crossing the street reads "Texas Headquarters" as a welcome. At the left side of the photo, the Chihuahua Exchange, Casa de Cambio, was managed by Miguel Gutierrez and was in the City National Bank Building. On the far right, people watch the parade from the balconies of the Herald building.

NOTES ON THE PHOTOGRAPHS

These notes, listed by page number, attempt to include all aspects known of the photographs. Each of the photographs is identified by the page number, a title or description, photographer and collection, archive, and call or box number when applicable. Although every attempt was made to collect all data, in some cases complete data may have been unavailable due to the age and condition of some of the photographs and records.

II THE MCGINTY CLUB PICNIC
El Paso Public Library,
Aultman Collection
A5983103

VI THE RIO GRANDE VALLEY BANK AND TRUST
El Paso Public Library,
Aultman Collection
A5570

X MONTANA AVENUE
El Paso Public Library,
Aultman Collection
A5847

2 THE LONE STAR BUILDING
El Paso Public Library,
Aultman Collection
A0903088

3 SAN JACINTO PLAZA
El Paso Public Library,
Aultman Collection
A0904090

4 ADOBE HOME
El Paso Public Library,
Aultman Collection
A0411091

5 MULE CAR TROLLEY
El Paso Public Library,
Aultman Collection
A0376092

6 FORT BLISS AT HART'S MILL
El Paso Public Library,
Aultman Collection
A0278093

7 SOUTH EL PASO STREET
El Paso Public Library,
Aultman Collection
A0269094

8 WAGONS AND OXEN
El Paso Public Library,
Aultman Collection
A0268097

9 PIONEER PLAZA
El Paso Public Library,
Aultman Collection
A5928099

10 LIGHTBODY AND JAMES STORE
El Paso Public Library,
Aultman Collection
A0373100

11 FRANKLIN SCHOOL
El Paso Public Library,
Aultman Collection
A0332104

12 INSIDE EL PASO COUNTY COURT HOUSE
El Paso Public Library,
Aultman Collection
A5895105

13 THE PALACE HOTEL
El Paso Public Library,
Aultman Collection
A5669138

14 THE EL PASO HERALD
El Paso Public Library,
Aultman Collection
A5714108

15 MINE AND SMELTER SUPPLY COMPANY
El Paso Public Library,
Aultman Collection
A5283106

16 THE EL PASO HERALD BUILDING
El Paso Public Library,
Aultman Collection
A5628

17 HOTEL ORNDORFF
El Paso Public Library,
Aultman Collection
A5218110

113 **EL PASO POLICE DEPARTMENT**
El Paso Public Library,
Aultman Collection
A5281

114 **EL PASO DAIRY COMPANY**
El Paso Public Library,
Aultman Collection
A0318

115 **THE BIJOU THEATRE**
El Paso Public Library,
Aultman Collection
A5432

116 **GEM SALOON**
El Paso Public Library,
Aultman Collection
A5332124

117 **TRAFFIC AT MILLS AND MESA** El Paso Public
Library, Aultman
Collection A0371

118 **EL PASO BASEBALL TEAM**
El Paso Public Library,
Aultman Collection
A0359

119 **EARLY RACE CAR**
El Paso Public Library,
Aultman Collection
A5030

120 **THE GRECIAN THEATRE**
El Paso Public Library,
Aultman Collection
A5554

121 **THE ALHAMBRA THEATER**
El Paso Public Library,
Aultman Collection
A5270

122 **THE ADVENTURERS CLUB**
El Paso Public Library,
Aultman Collection
A0521

123 **HUPMOBILES**
El Paso Public Library,
Aultman Collection
A5447

124 **FIRST NATIONAL BANK**
El Paso Public Library,
Aultman Collection
A5116114

125 **WESTON'S PERFECTION BREAD BAKERY TRUCK**
El Paso Public Library,
Aultman Collection
A5706

126 **FLORENCE MILBY**
El Paso Public Library,
Aultman Collection
A5844

127 **THE UNIVERSITY CLUB**
El Paso Public Library,
Aultman Collection
A5996

128 **CAMP GRANDE SIGHTSEEING COACH**
El Paso Public Library,
Aultman Collection
A5908

129 **UNITED STATES CAVALRY OFFICERS**
El Paso Public Library,
Aultman Collection
A0141

130 **UNITED STATES ARMY INFANTRY**
El Paso Public Library,
Aultman Collection
A0370

Printed in the USA
CPSIA information can be obtained
at www.ICGtesting.com
JSHW072024140824
68134JS00042B/3770

9 781683 368281